SANTA ANA PUBLIC LIBRARY

D0687067

The Flowering Dream

The Flowering Dream

The Historical Saga of Carson McCullers

Nancy B. Rich

Chapel Hill Press

© 1999 by Nancy B. Rich

Published by:
The Chapel Hill Press
100 Eastwood Lake Road
Chapel Hill, NC 27514
919/942-8389
Fax: 968-3274

Printed in the United States of America

ISBN: 1-880849-14-3

TABLE OF CONTENTS

Foreword

Around 1970, while in search of a "gothic" novel by a Southern writer, a colleague recommended that I read Carson McCullers's first novel, <u>The Heart is a Lonely Hunter</u>. As I read it, I found nothing unusual or gothic in the novel, only a description of life in the South as I knew it from growing up in North Carolina. My parents, Dr. James O. Bailey and Loretta Carroll Bailey, were both known internationally for their academic and creative work, and I was raised in an environment in Chapel Hill, NC where many intellectuals and university professors were regular guests in our home. Issues of discussion during that period paralleled many of the issues McCullers considered in her novels, and as I studied her work in my adult years I became increasingly appreciative of her focus on people's rights, labor issues, racism, and other flash points of the indigenous culture in the South during her lifetime.

Upon further reflection over the years I have realized that Carson McCullers had a very definite purpose in her work that has escaped most reviewers, and that her novels were a statement on the motives, emotions, and actions found in the daily lives of regular people in the South during the middle of the 20th century. The focus of this book is that Carson McCullers was a highly talented writer with a vision of where she was going with her series of novels, and that these novels provide an historically accurate cross-section of life in the South.

1

THE FLOWERING DREAM

*"The past has been and still is an inescapable element . .
not as myth, not as a retreat, not as a mask, but as a
mystery to be understood, as a burden to be borne, as a
guilt to be expiated, and as a pattern which can——if
anything can——point us to the future."*

– Hugh Holman in The Immoderate Past

Carson McCullers undertook one of the most ambitious literary
projects in the United States in the twentieth century, but neither
that fact nor the result has been recognized because her work has
not been fully understood. Although she is considered a major
southern writer, her novels have been seen, generally, to be
emotional rather than intellectual, and as somewhat lacking in artistic
control. Ironically, her theme is that knowledge is essential to
American freedom, and her artistic scheme is so tightly controlled
that its parts are barely discernable within the tightly woven fabric of
her work. Her general theme is freedom. Her approach is the
question of how it can be achieved, and her specific focus is the need
for unity, of thought (knowledge), of spirit (communion with God),
and between men, morally, socially, and politically. Moreover, this
theme is developed through all five of her major works to form what
amounts to a saga of man's struggle for freedom in the western
world.

Her first novel, The Heart Is a Lonely Hunter, was published
in 1940, when she was only twenty-three years old, and it received
rave reviews. The publication of three more novels in quick
succession between then and 1946 brought more accolades, and the

young writer seemed launched on a promising career made even more optimistic by the opening of a dramatized version of her novel, The Member of The Wedding, on Broadway in 1950. But although she lived another seventeen years, she produced only two more major works, and these did not live up to public expectation. Her play, The Square Root of Wonderful, received mixed reviews and closed after only forty-five days on Broadway in 1957. Her 1961 novel, Clock Without Hands, fared little better. By 1977 it had been declared "an artistic disaster"[1] and is now out of print. So essentially, McCullers's reputation as a major southern writer rests on the strength of those first four novels which appeared between 1940 and 1946, when she was in her twenties. This seems curious, since later works would presumably indicate the effort of a more mature and experienced hand. What is even more curious, however, is that McCullers should have achieved her currently prominent place in southern literature on the basis of four novels about which there is no consensus as to what they say or how well they say it. In 1966, her first biographer, Oliver Evans, stated flatly that Carson McCullers was "possibly the most controversial living American writer"[2] and in 1998, the controversy continues.

Most of the controversy revolves around her first novel, The Heart is a Lonely Hunter. This story is set in a small southern mill town, and it defines the essence of such towns as they existed during the Great Depression of the 1930's, but there is no agreement among critics as to its theme. To some, its exploration of the problems of racism, poverty, and labor suggest that it is a social protest novel,[3] and to a noted critic of the genre, there is no doubt about the author's intention: Leslie Fiedler describes this novel as the last of the "proletarian novels of the era."[4] But the vast majority of readers have found the socio-political aspects of this work to be "peripheral," and believe its theme to be loneliness, spiritual isolation, or the search for God.[5] This belief has persisted for more than fifty years, and represents a remarkable testament to McCullers's skill, as a recent critic's comment attests. What

McCullers's "earliest novel lacked in . . . form," she says, "it made up in intensity and in an understanding of the searchings of the heart."[6]

This consensus is, no doubt, the reason for McCullers's good standing in southern literature. It is also essentially patronizing, and until the extent of her artistic expertise is known, her place in American letters will not be secure. The most serious aspect of controversy relative to Carson McCullers's work is whether her novels are artistically planned and unified.

Early reviews of The Heart Is a Lonely Hunter are enthusiastic, but ominous in their foreshadowing of the debate about the extent of her artistic skill. The reviewers focus primarily on the fact that such a young writer could perceive so clearly so much about "the lonely hearts of men, women and children,"[7] and so compellingly convey "the quality of despair."[8] Any allusion in these reviews, however, to the artistic control of this novel are negative. One reader writes that McCullers "reveals no special gift for story telling,"[9] and another describes the book as "uneven."[10]

Twenty years later, after all of McCullers's novels have been published, articulation of concern about her artistic expertise has become serious. One scholar sees form in The Heart Is a Lonely Hunter as "open and suspended."[11] Another describes the form of the novel as a "failure,"[12] and still another, seeing "an overabundance of material" in the work, says, "The richness of the novel is both the source of its continuing appeal and its basic weakness; the ultimate effect is that of a profusion that cannot be contained." The work, he concludes, "is lacking in artistic control."[13] In essence, says another, McCullers "speaks not to the intelligence so much as to the untutored emotions."[14] It should be noted here that these comments appear to be intended to be complimentary, to convey the idea that McCullers achieved an effect that is difficult to attain in literature in spite of the fact that her work appears to demonstrate little or no skill in the art of fiction. Whatever their intention, however, the

implication is that her writing is governed by emotion as opposed to intellect.

Meanwhile, some readers were finding evidence of artistic design in The Heart Is a Lonely Hunter. Her biographer cites two reviewers as finding that "the structure of the book is strictly symmetrical based on the character grouping in "satellite fashion around Singer."[15] Another reader sees unity in this novel because "the central and controlling metaphor of Carson McCullers' fiction is a chain constructed with links of love,"[16] and still another suggests that this concept, which he attributes to being Platonic in origin, is relative to several other of McCullers's novels as well.[17]

By the decade of the seventies, more precisely defined patterns of design are being seen. One essay traces the way the form of The Heart Is a Lonely Hunter follows the structure of a musical fugue,[18] and by 1976 one reviewer is convinced that this work is a complex mathematical design. Its structure, he says, "is based on a far more elaborate and occult symbolism than is first suspected by a casual reading, and each chapter of the novel fits into an almost mathematically determined position Mrs. McCullers created a Divine Comedy whose symbolic architecture and symmetry are everywhere in harmony and which reveals a profound sense of form and artistic completion."[19] By the eighties, another reviewer is convinced that design of McCullers's first novel is derived from her knowledge of music. This article declares that "its structure is based on Beethoven's Third Symphony, his Eroica."[20]

While most of the designs found were in The Heart Is a Lonely Hunter, one critic noted that the café itself in The Ballad of the Sad Café provided a structural basis for theme,[21] and the café as metaphor was also observed to be part of the structural planning of the other novels.[22]

One implication of these findings is that McCullers had tight control over her materials in order to have produced so many designs. The other is that she is no wunderkind whose only claim to fame is expressing how it feels to be lonely; her work is intellectual,

and exhibits a fairly extensive knowledge of history, religion, philosophy, music and mathematics.

Why, then, do some readers see it lacking in artistic control? One reason may be that even in McCullers's first and most widely reviewed novel, readers have not been able to agree as to which character is its hero. Another is that (also in this story) there is an apparently major character (Antonapoulas) for whom there appears to be no artistic rationale. But the main reason is that no one has yet fully recognized this author's theme in this or any other of her works. That theme is defined in the first novel and continues through the other works.

Loneliness and spiritual isolation are certainly a large part of it. In fact, McCullers specifically stated in the outline of her first novel that her theme was "man's revolt against his own inner isolation and his urge to express himself as fully as is possible."[23] But she prefaced that statement with another: "The broad principal theme of this book is indicated in the first dozen pages." Since those pages deal with deaf mutes, readers appear to assume that they are symbols of isolation and need for self expression.

That assumption is correct—as far as it goes—but it is way short of recognizing the extent of this author's intellectual grasp and artistic skill. Specifically, the mutes are symbols of the handicaps of the South during the time of the novel, which is the thirties. Antonapoulas, who is a symbol of both religious and political ideals, reflects southern distortion of both. He is constantly praying (but doesn't know which God to address), has no respect for the people on the street, and is prejudiced against both black people and women (as indicated by his prejudice against these pieces in the chess game). The other mute, Singer, is a symbol (or image) of church and government as they are perceived by the people of the South—as the chess game indicates. He loves to play the game, which involves moving the chessmen (who represent both ecclesiastical and governmental authorities as well as common "pawns") around, but few Southerners will play the game with him.

Following the few pages which define the symbolic function of these two characters, Antonapoulas leaves town, and Singer moves into a boarding house—and at this point McCullers appears to have an error in her text. She seems to forget that Singer is in a boarding house, and in the very next sentence declares that "he ate his meals at a restaurant . . ." This was not an error; it was deliberate repetition for the purpose of drawing attention to Singer's symbolic role. As a symbol of government, he "lives" with (and draws sustenance from) a select group of people (presumably educated people) but he must support the general public (pay his food bill at the café), and they, in turn, must serve him. His symbolic identity having thus been conveyed, the definitive chapter ends, and the "story" begins.

The major characters in the novel, all of whom look to Singer for help, represent different segments of southern society. Biff represents business, or commerce. The others stand for major social problems that cause disunity (and all of McCullers's works focus on disunity in order to demonstrate the need for unity, which is her theme). The major problems in focus in this first book are labor, women's rights and racial discrimination. Of these, the one that represents the most prominent form of disunity of the era is racism.

So racism is the narrative focus in all of McCullers's major works,[24] but this fact has not been noted because the importance of point of view in her work has not been recognized. She is a psychological realist. Racism appears prominent only to the extent that her characters recognize it as a problem. In the first novel, which is set in the thirties, the effects of racial discrimination are seen in the black characters' illiteracy, poverty, social humiliation and cruel treatment by law enforcement. But these things achieve only slight prominence, and then only because an educated black man talks about the need for black men to be free and tries to obtain some justice for them under the law. Similarly, racial discrimination is seen in The Member of The Wedding, but it is not a subject much on the minds of the characters, so it does not seem prominent. It is extremely prominent in the last novel because Clock Without Hands

is set in 1953-54, when integration was on everyone's mind as the Supreme Court considered it. But racism does not appear to even exist in either The Ballad of the Sad Café or The Square Root of Wonderful because it is not consciously on the minds of the dominant white characters, and there appear to be no black ones (except in the Coda of Ballad). This is deceptive. There are black characters in both, and the action in these works revolves around how the characters in these two works will deal with racism as a result of the central event in the plot of these works.

Ironically, readers have either ignored, or failed to identify the central event in McCullers's works, even though it governs development in all of them. It is a historical event of major importance which has the potential for either reducing or increasing the possibility that American Democracy as our forefathers conceived it will succeed. In Ballad, which is a "memory" drama, the event is the Civil War, though paradoxically the war itself is not part of the action, except in the narrator's brief allusion to his perception of the homecoming Confederate soldier. Some of the story deals (by allusion) with the period before the war; most takes place during the four years following the war, and it deals with the struggle between the aristocracy and the illiterate masses as to who will rule the South as a result of the war. In The Heart Is a Lonely Hunter, it is the Great Depression, during which period the South not only established a racially discriminatory law (Jim Crow) that defied national authority, but was plotting to build a political party (Dixiecrats) strong enough to achieve dominance in Washington. In The Member of The Wedding the event is World War II, the "war for Democracy," where we see (in the person of a young girl) a segment of the southern middle class awakening to the irony of fighting in a war to stop tyranny abroad while they face it in their own "kitchen" every day and cannot escape it due to legal and "paternal" authority. The "event" of The Square Root of Wonderful is the Fair Housing Act of 1947, which, (like the Civil War in Ballad), is not specifically mentioned in the play but which shapes the action.

15

The central event is identified in diverse ways throughout each work. In <u>Ballad</u>, for instance, Cousin Lymon's recital of his and Miss Amelia's family genealogy relays information which not only specifically dates the action but, by historical allusion, puts it into perspective within the parameters of the American Dream and historical (race-related) events in the South between 1776 and the Civil War. In <u>The Square Root of Wonderful</u>, the single, most obvious clue is a literary allusion to Zora Neal Hurston.

But neither historical nor literary allusions in McCullers's work have been critically noted to any real extent. One reason is that her theme has not been fully defined, but there is another: many allusions relate to her artistic designs, and these have not been defined at all (except that two of them have been noted in the first novel—and they extend through all of the works). So the average reader might recognize an allusion to Hurston, for instance, as relating to the theme of loneliness and spiritual isolation. But who ever heard of somebody called "Zinzer" (an allusion from the same work)? And if they had, what sense could they make of the text of this work (which appears to deal with viruses) in terms of the play's apparent theme of loneliness? The answer is, none whatsoever, for it deals not with that theme directly but with one of the artistic designs which support the larger theme. These designs need to be recognized and defined before allusions to them will be clear and meaningful.

One was identified (in <u>The Heart Is a Lonely Hunter</u>) more than twenty years ago by a leading McCullers scholar, Dr. Joseph Millichap, who maintained that <u>The Heart Is a Lonely Hunter</u> was designed around a tripartite linear progression based on historical time, in which the relative spiritual conditions of the characters are measured by their reactions to social events, or the threat of them.[25] This is correct, except that it applies to all of McCullers's major works (not just one) and it serves not only to measure the characters' reactions to social events, but to put those reactions into historical perspective.

Specifically, the design consists of a political parable and a religious allegory which develop concurrently with the narrative. The narrative realistically portrays life in the South at a specific time, and on this level of development, four of the five works of the saga follow in chronological order, with the first, The Heart Is a Lonely Hunter, being set in 1939, the second, The Member of The Wedding, set in 1943, the third, The Square Root of Wonderful, in 1948, and the last, Clock Without Hands, in 1953-4 The Ballad of the Sad Café is out of order because it deals with the past. It actually takes place in 1929, as the opening and closing pages indicate. However, it is a memory drama so the bulk of the story deals with the southern past as the narrator remembers it, and his memory time extends from 1776 to 1929. So time on the narrative (social) level of these works' development actually begins in 1939 and ends in 1954, with one brief allusion (in Ballad) to how Southerners viewed their past (from the perspective of 1929). The narrative focus of all these works being racism, then effectively, the narrative level of development covers the fifteen formative years of the Civil Rights movement in the South, but puts that era into perspective with characters' memories of their past.

The parable, which develops symbolically, alludes to political matters which have had or are having an effect on freedom in America. Time in the parable extends from 1776 to 1954, and the purpose of the parable is to measure the extent to which America had, by the date of each of the works, reached its political goal of freedom as compared to its avowed ideals as articulated in the Declaration of Independence and the Constitution.

Similarly, time in the third level of development begins with a significant historical moment. Time in the imagistically developed level of the religious allegory begins with the Exodus out of Egypt, for this represents, in the western world, the origin of the idea that freedom among men must rely not only on their own efforts but on the guidance of a God who promises freedom through spiritual

commitment. Each of McCullers's works deals with a segment of the religious history of the western world.

In all three of these linear developments, the historical event or situation to which the allusion, the symbol or the image refers is associated with a major historical event which aimed at unity toward the goal of freedom but which failed because of disunity.

The other major artistic design which continues through all the major works (and serves to link them) has not, to my knowledge, been identified, though many parts of it have been noted. This design is also tripartite, but not linear. It develops metaphorically and deals with knowledge—or rather three aspects of knowledge. These are: mathematics, language, and the arts. These designs take many forms and are seeded liberally throughout the five works. They serve as a basis for the construction of the works and a means of linking them. The mathematics paradigm may be seen in ways as simple as a street address or the number of chapters or characters, or as complex as a geometric design. The designs which focus on music may be as obvious as knowing the color of piano keys or so complex as to require some knowledge of how a fugue is constructed or who it was that gained notoriety by following Mozart around. As for the language design, it includes just about every aspect of linguistic communication, but is chiefly seen as semantic ambiguity. The one thing that all these designs have in common, however, is that they are all incomplete. Even minor details illustrate the idea. For example, Mick lives at 103 4th Street. The "2" is missing. The metaphors are always incomplete to suggest man's incomplete understanding, and the need to work toward completion (also known as worldly unity).

With these two designs, McCullers created a literary landscape which appears to be unique in depth and complexity, if not in kind, in American literature, and here is why. Her narrative focuses on one individual, the "hero." A tripartite linearly developed design provides insight into his social, political, and religious heritage. Another tripartite design, developed metaphorically, focuses on the three aspects of knowledge which he needs to acquire if he is to

effect social, moral, and political change. Thus a formula emerges: it is 3 + 1, and it is central to McCullers's work. In fact this formula is the foundation of both her theme and her artistic design.

First, it represents metaphorical logic, which is illustrated by "3" circles plus "1" more which is created when the original "3" overlap to indicate that they have something in common. This is called the Venn diagram. There is graphic evidence among McCullers's papers at the Humanities Library at the University of Texas that she used it in the plotting of <u>The Member of The Wedding</u>.[26] She also uses it as an epiphanal element in her first novel. In fact, it is the only method by which the crossword puzzle which appears in the final pages of <u>The Heart Is a Lonely Hunter</u> may be worked—and the solution to that puzzle defines the three aspects of knowledge that her metaphorical design develops. Thus the Venn diagram is used to allude to the theme of need for worldly completion (knowledge). If the person working that crossword puzzle has sufficient knowledge to fully complete the puzzle, he will find that its answers link this design to a second epiphany (which relates to the religious allegory) by alluding to a linguistic problem relating to the identity of one of the prophets.

But the formula 3+1 has another meaning, and it, too, is an essential element in McCullers's work. It is the Pythagorean formula for reaching Divine Unity. It consists of three levels of understanding man may reach through his physical, social and intellectual powers, plus one more: spiritual communion with God. This formula is, like the Venn diagram, displayed as an epiphanal element in the final pages of the first novel—in the form of the main character's vision. In this vision, Brannon has a brief sense of the "passage of humanity through endless time . . . and those who labor and of those who—one word—love." The configuration consists of three words, all of which mean the same thing (if they are capitalized) plus one more ("who"). But what is its meaning? Readers have assumed it means no more than a moment of "illumination" but this is because they are not aware of the artistic design or of how McCullers uses it. Like the

formula, the design consists of "3" worldly attributes plus "1" spiritual one. But sometimes (for reasons which will be clarified later) the elements of the formula may shift place. For instance, the "3" may indicate that a man has attained three levels of understanding, such as his physical world, his social world, and his spiritual world—but lacks "1" other: an intellectual understanding. This is the case with Brannon and this vision.

Brannon has throughout the novel been shown to have achieved spiritual communion with God. It is demonstrated in his deep concern for others, his compassion for them and his attempts to help them. He is caring even to the point that he will not kill a bee, but opens a window so it can be free. And in the chapter in which the vision occurs, he has kept his café open all night in case someone might need him, and his thoughts are on others' welfare.

But he is deficient in one of the other levels of understanding man must have if he is to meet the Pythagorean requirement for achieving Divine Unity, and that is his intellectual power. He is only moderately well educated. He notices misspellings in the newspaper, and he listens to the world news on the radio, and he works crossword puzzles. But he is not concerned with the news in the newspaper, shows no thought as to the implications of "the crisis voice" on the radio (about Hitler's threat to peace in the world) and quits working the crossword puzzle because he has little interest in exploring the meaning of words and lacks the education to find the answers anyway.

So in McCullers's description of the vision, her "hero" instinctively associates man's destiny with the words "one," "word" and "love" but does not perceive that if capitalized, all these words mean the same thing, "God." Thus the semantic difficulty in the vision relates the vision to the crossword puzzle, suggesting that while a fleeting vision may be all well and good, one must have knowledge to understand it as well.

As long ago as 1976, Professor Edgar MacDonald asserted that knowledge was the theme of <u>The Heart Is a Lonely Hunter</u>,[27] and

he supported this opinion with convincing evidence that her work was based on philosophical and mathematical concepts (which it is). Moreover, he concluded that "for Carson McCullers, knowledge obviously meant "freedom," (p.185) so in a sense, he actually identified her theme (in this one novel, at least). He also recognized the importance of numbers in her work, and concluded that the number "3" seemed to have an "ominous" connotation, and that "4" was "symbolic of communion, happiness, [and] realization." (p 175). He was right, but nothing in McCullers's work is that simple.

Her theme is freedom, but her working theme is unity, and it is on this theme that her artistic design is based. It is unity in three forms: intellectual, spiritual, and worldly. Graphically depicted (though backwards, as in the reflection of a mirror) McCullers's theme looks like a formula: 3+1.

We have already seen two parts of that formula in McCullers's first novel. One consists of two tripartite designs (one developing linearly and the other metaphorically) which develop parallel to the narrative, and serve to suggest the hero's need for knowledge of religious history and of language, mathematics and the arts.

A second consists of two other designs, also reflecting the formula 3+1, which appear in the form of the puzzle and the vision. They provide a measure of the "hero's" ability to use the knowledge he has to logically work the puzzle and spiritually commune with God.

There is a third design as well, which we have not identified. Like the one dealing with Divine Unity, it is derived from the Pythagoreans' Holy Tetractys, but it differs in that it represents a "working" formula for achieving both worldly and Divine unity. Its point is that man must act on what he knows.

The Pythagoreans believed that the universe was orderly, and that all its parts were related to each other mathematically. Further, they reasoned that if their world were translated into mathematical concepts, they might more accurately define it. So they converted the Tetractys concept to a mathematic design with the levels of reality

designated by dots representing each level placed on a separate line (one dot, then two, then three, then four) and enclosing this configuration with straight lines connected to each other to form a triangle.

Thus literally, it consists of a group of numbers which have special meaning only if they are seen as having a relationship to each other, which can be provided only by man. He must take action to indicate that these numbers together are special. He must draw three lines around them to enclose them. Thus a formula is derived: the formula is 3+1 (three lines plus one "hand" to draw them—and hands are a central symbol in McCullers's work, signifying need for action.

This design complements the other two. The first focused on need for knowledge; the second showed need to use knowledge to solve problems; the third indicates the need to act on what you know. It is a "working" formula.

And it "works" in McCullers's artistic scheme in more than one way. When the Tetractys is depicted as four lines of dots on a page (1+2+3+4) it yields the number 10. The number 10 is the magic number, for the 1 represents unity (One, or God) and the zero represents completion (when it is called by its other name, a circle—and semantic ambiguity is at the heart of McCullers's semantic design). Thus McCullers's reader must bring his knowledge to her work for it to have meaning. If we know that the circle means completion, and that the mathematical formula for unity and completion is a triangle, we can determine the meaning of the two central symbols at the center of The Heart Is a Lonely Hunter, for instance, and this has puzzled readers for a long time. One of these symbols is a circle with Singer in the center, surrounded by all the other characters except Antonapoulas. In terms of theme, this circle indicates that man has completed one step in his journey toward freedom: he has created a government designed to help the people, and the people's lives revolve around it. Or you might say that the circle represents a wheel, suggesting that man's work has resulted

in the completion of a worldly design aimed at freedom. But this circle is closely associated with another central symbol in the work: Singer's dream. In this dream, the four characters are in a line on the bottom step of a staircase, Singer is in the middle, and Antonapoulas is at the top. The configuration is a triangle, similar to the Tetractys in shape but differing in formation, for it's Singer's dream, and therefore the American Dream of a people united with government under God. What is missing in this dream are the lines around the formation (to enclose the figures in a triangle). In other words, what is needed is the hand of man (action) to make the dream exist in worldly (mathematical) terms.

The triangle and the circle were prominently displayed as symbols of the "World of Tomorrow" at the World's Fair in New York in 1939. They were called the Trylon and the Perisphere, and had been widely publicized prior to the opening of the Fair, during the period when McCullers was working on this, her first novel. They were symbols of hope for the future through unity and completion.

The title of McCullers's final novel, Clock Without Hands, while an obvious allusion to the theme of that work (in terms of its relating to a time when government has made a racially unifying decision which requires, to be effective, the support of the people) is also, literally, an image of a circle with numbers, but lacking the straight lines (hands) which might, as in the Tetractys formation, create a triangle.

This title is also an allusion to her first novel, which we know as The Heart Is a Lonely Hunter but which she called The Mute, and for good reason. The word "mute" implies the need of hands to communicate. It is also ambiguous, for it can be can be singular or plural, and it is the name of a musical device, so it alludes not only to the duality of her theme, and the specific nature of her artistic devices (semantic ambiguity and music in particular) but also to the need for unity (communication)—her working theme. The titles of her first and final novels, then, not only convey information as to the nature and intent of her work but inform us that all of her five major

works are linked by theme and artistic design to form a saga of man's struggle throughout the history of the western world to achieve freedom among men and communion with God.

Carson McCullers was a Southerner who hated the injustice, inequality, and ignorance she saw around her as she walked the streets of Columbus, Georgia as a child. But she had faith that over time, with increased knowledge, through law and changing attitudes, harmony between black men and white, and unity between North and South would come about. She set out to demonstrate through the historically oriented levels of thematic development in her work that man has persisted in his idealistic pursuits throughout his past despite terrible setbacks and overwhelming odds. Similarly, she documented the shifting perspectives demonstrable in her characters as she evoked the extent of their awareness and measured their increasing sensibility through their points of view, underlining the effects of improved education with her structural designs related to knowledge.

The evolution of awareness is slow, and that is one reason that all of her novels (and her play) seem pessimistic, disunified, and incomplete. But when they are seen as parts of a continuing saga, the perspective is essentially optimistic, for they reveal that despite setbacks in the past, man has never lost sight of his spiritual aspirations or his political ideals, and that from time to time he actually takes action to achieve or implement them. The literary achievement of Carson McCullers was to create an artistically unified epic which records the slow flowering of the dream.

THE HEART IS A LONELY HUNTER

"Not like the brazen giant of Greek fame,
With conquering limbs astride from land to land;
Here at our sea-washed, sunset gates shall stand
A mighty woman with a torch, whose flame
Is the imprisoned lightning, and her name
Mother of Exiles. From her beacon-hand
Glows world-wide welcome; her mild eyes command
The air-bridged harbor that twin cities frame.
'Keep ancient lands, your storied pomp!' cries she
With silent lips. 'Give me your tired, your poor,
Your huddled masses yearning to breathe free,
The wretched refuse of your teeming shore.
Send these, the homeless, tempest-tossed to me,
I lift my lamp beside the golden door!'"

— Emma Lazarus, "The New Colossus"

In the outline which McCullers sketched in preparation for writing her first novel, she said its theme was "man's revolt against his own inner isolation and his urge to express himself as fully as is possible."[1] This is a clear reference to man's need for communion with God (spiritual unity) and knowledge (intellectual unity). Man's need to overcome his sense of isolation is evident in his long struggle to commune with a power greater than he (God) and the desire for freedom of expression is a worldly need which man has sought to fulfill through the establishment of governments. The religious

allegory in the structural architecture of <u>The Heart is a Lonely Hunter</u> is based on the former; the political parable on the latter. In the structure of McCullers's works, references to the history conveyed by allegory and parable always have a dual meaning, one which applies to religious aims, the other to political goals.

McCullers followed her reference (in the outline) to these two aspects of theme with a series of what she called "counter themes," and the gist of these is that although man has succeeded in creating "some unifying principle or God," his own personal inadequacies and his social failures have thwarted his idealistic aims. These comments point to the narrative or realistic level of development which illuminates the reasons for man's failure to fully achieve his religious and political goals. This level focuses on man's incomplete understanding (and need for knowledge, which the linear and metaphorical designs indicate). It shows that having created his own image of God (by whatever name this God is given), man ignores its relevance to his own life, and that having established a government which ostensibly guarantees his right to express himself fully (democracy), he does not follow its precepts himself.

Thus paradox is clearly central to theme: in one sense man has accomplished his goal (the establishment of church and government), but in another, he has not. In her outline of <u>The Mute</u> McCullers alluded to this paradox with respect to the political paradigm when she called this novel "an ironic parable of Fascism." She meant that in ironic contrast to European Fascism which denied liberty through force, American democracy denied liberty through default—by failure of government to speak to the problems of the people—and conversely, failure of the people to speak to the government about this. This explains Singer's being mute, for he is the symbol of American government. Although he appears to help the other characters in the story with their problems, this is an illusion: their illusion. In fact, in Chapter 7 of Book II, he declares that he does not understand their problems, and certainly he never "lifts a hand" to solve the problems of labor, poverty, or racism: his hands are

symbolically in his pockets throughout the story. The reason is shown (also in the central chapter of the novel) when the other characters meet in his room at the same time, and nobody says a word. They represent different political factions: Mick represents women; Copeland, Blacks; Blount, labor; and Brannon, business. Behind them in the dream image are "uncounted crowds of people kneeling in the darkness." With the majority ignorant and the factions unable to agree, government is mute.

Like Singer, Antonapoulas is a deaf mute. Also like Singer, Antonapoulas was functional and a part of the work force in the town at the beginning of the novel. But unlike Singer, he was not known to the main characters (except for Biff, who was said to remember him from time to time).

Antonapoulas is a symbol of the principles underlying American government, and this role is clearly indicated in the opening pages of the novel. He and Singer are described as "very different" but they "were always together," and the "one who steered the way" was Antonapoulas. Representing both the political and the economic principles of American democracy, he is associated with capitalism through his symbolic role as cousin to a store owner who, it is said, "did not know much about the American language but he understood the American dollar very well." McCullers having Antonapoulas's capitalist cousin represent the cause of misfortune for Antonapoulas and the separation of him and his friend Singer appears to be a brief and isolated incident intended to suggest that capitalism was a matter of public concern in the thirties. However, there is no further mention of the cousin in the novel, so it appears that capitalism per se was not of great importance to her and more specifically not of particular relevance to the saga. Antonapoulas's more important role in this novel is that he represents the ideal, the principle underlying the political system. Described as a "dreamy Greek," he is intended to reflect that combination of Greek democracy and Christian idealism which constitutes the basis of the American political system.

A central metaphor in the opening chapter indicates that both Antonapoulas and Singer have symbolic roles relative to the religious allegory as well as to the political parable. These roles are defined partly in the chess game. Singer loves the game, for he likes to move the chessmen around, and the playing pieces of this game have the names and shapes of both ecclesiastical and governmental figures. Singer is a symbol of both church and government, the worldly edifices through which man communicates with the God he believes in and the constitutional principles he aspires to. Singer's love for and commitment to Antonapoulas, who is the symbol of those ideals (both God-head and government) is the focus of their relationship throughout The Heart is a Lonely Hunter.

Antonapoulas has no interest in moving the chessmen around. He learns "to make a few set opening moves," but is puzzled by the practical business of the game; he does not understand the female chess pieces and prefers the white "men" over the black "men" and this historical allusion associates him with the United States Constitution.

In her outline, McCullers referred to Singer specifically as a symbol, but she did not call Antonapoulas a symbol because he represents an ideal, and is, therefore, more precisely an image. Furthermore, in representing religious idealism he is an image of something which has no image because individual perceptions of God differ. She therefore conveys his symbolic identity by associating him with the way that men associate themselves with God, through prayer. And since she is dealing with religion as it prevails in essentially Protestant and Catholic America at the time, Antonapoulas is said to wear a cross around his neck and be constantly praying.

The details concerning his prayer more precisely confirm the author's intent. McCullers says that his mouth shaped the words "'Holy Jesus,' or 'God,' or 'Darling Mary'"; Antonapoulas cannot speak; God does not have a mouth; yet Singer understands the words which Antonapoulas conveys with his hands, which suggests an

image of the way people understand God. God is "the Word" and this idea is conveyed through writing, as the mute conveys meaning through sign language or shaping of a word.

The importance of recognizing the diverse ways that McCullers manipulates the language throughout her work cannot be overemphasized.

The crossword puzzle which occurs in the final pages of Heart is unfinished because Brannon is too lazy to look up a word. McCullers means for the reader to finish it. Biff identifies the first answer as Mona Lisa, and the second as Mendicant. "Two horizontal was some word meaning to remove afar off. A six-letter word beginning with "e." Brannon gives up, but a probable answer is "exiles." With the addition of this word, the puzzle's configuration indicates three areas of McCullers's concern about the South of her time: the arts (Mona Lisa), religion (mendicants), and socio-political matters (exiles).

If the logic of the Venn diagram is applied to the puzzle, it can be seen that the answers to it indicate a number of other things. One is semantic ambiguity, for there is another word for each of the answers in the crossword puzzle. The Mona Lisa is also known by the name of its model, La Giaconda; the Mendicants consisted of multiple religious orders; and there are two historically prominent periods referred to by the word "exiles": enslavement in Egypt and the Babylonian captivity.

But although we now have two answers to the puzzle, we should, within the context of McCullers's three-plus-one formula, find a third, and the implication of one more.

We can. Brannon considered the words "Eloign" and "Elapse," and then quit trying. We have identified the missing word of the crossword puzzle as "exiles," but there are other possibilities, and except for the word "escape," which does not appear to quite fit the definition "to remove afar off," the ordinary dictionary lists only three: Exodus, Elijah, and Elisha. The word "Exodus" appears to be the most logical choice, since it has something obvious in common

with the two already established words: their implicit representation of three different historical periods. The Mona Lisa is associated with the Renaissance; Mendicants are associated with Christianity; and the Exodus is associated with Judaism.

What about Elijah and Elisha? Both are also associated with the Exodus, so either would suffice to suggest Judaism, and they might suggest something else as well. There is some historical confusion as to whether they are one and the same, with Elisha simply representing a misspelling of Elijah's name. So filling in the crossword with either of them might point to the importance of precision in identification, e.g., how can the two be shown to represent the same or different persons. Perhaps by what their names represent. In Hebrew, Elijah means "Jehovah is my God" while Elisha means "God is my Salvation." The difference is that one represents naming his God and the other represents indicating a function of his God. So name and function of God then might become the point McCullers intends to convey. The name of the Hebrew God is Yahweh, and Yahweh is the God of Justice. The implications of the crossword puzzle, if carried this far in terms of exploration, are then that man has worshipped three different entities in the past, and each has had a different name and a different function. Yahweh's function was to bring justice to the world; Jesus's function was to bring love; Man's (i.e., the Renaissance) was to bring reason. Essentially then, the conclusion to be derived from the crossword puzzle's answers reflects the three-plus-one formula that is integral to McCullers's saga. There are three answers, and one missing (but in this case implied): unity among men as to their perception of the nature and function of God.

The crossword puzzle is presented in the last few pages of the novel, within which Brannon's vision also occurs. While the puzzle was, in the text, left uncompleted, the vision was left ambiguous.

The final word in this vision is "love," which readers have perceived as "an affirmation" of "universal Love" perceived by Brannon to be the answer to darkness.[2] But in fact, the word is not

capitalized, and Brannon is said to perceive nothing; he has no idea what the vision signifies. His having a vision at all suggests that he is at least the kind of man who, in comparison to others in the story, has the potential for being visionary, but he does not even think about the meaning of the vision; he turns away. All he has really seen is what we see, which is a word which is not capitalized, and is linked to two other words with a dash. Precisely, the phrase reads "one word-love."

This is a configuration of McCullers's three-plus-one formula. Three words are identified; the missing one is indicated by the dash (which is not a word). This fact alone tells us that to interpret the vision we need to know more than Brannon did. Earlier in the chapter, McCullers had indicated that Brannon was interested in correct spelling, and his trying to solve the crossword puzzle suggests that he has some interest in the meaning of words, but there is no indication in the novel that he is concerned about grammar. Yet McCullers directs our attention to its importance within the paradigm of the crossword puzzle, for the first letter given for the term which we identified was a small "e." Brannon's first guess was "Elapse" and he next thought of "Eloign"—neither of which should be capitalized. Influenced by the power of suggestion, I suppose, we followed suit and came up with answers which made sense, and which I feel sure McCullers intended us to do. But she also intended Brannon's error to highlight the importance of capital letters, for the vision follows the puzzle directly in the text, and recognizing the function of capital letters is the key to figuring out what the vision is all about. Since the phrase "one word-love" is in the context of a vision, the word "love" should be capitalized (as indeed, the critic's seeing it as "an affirmation . . . of universal Love" implies she did). The word "Love" is synonymous with the "Word," which is synonymous with "One," and all three (when thus capitalized) mean the same thing, God.

When completed, the puzzle and the vision are related and complementary (just as are the wheel and dream images which define

31

the dual theme). Man has called the object of his worship by a different name during the three periods implied in the puzzle: Judaism, Christianity, and the Renaissance. The vision calls for one name, oneness, unity—and to solve the puzzle that leads to it, knowledge.

Although Brannon did not solve the puzzle or see beyond the lower case meaning of his vision, he is the "hero" of the novel, for at least he recognized that a puzzle needed to be solved and got a glimpse of something beyond himself (which is more than the other characters did). Furthermore, in the opening statement of her outline of The Mute, McCullers stated that "the broad principal theme of this book is indicated in the first dozen pages,"[3] and Brannon is the only character that appears in these pages who is not either a symbol or an image.

At the end of the chapter, Singer hands him a note describing the menu he would like to have prepared for him at Brannon's café. That's all. Except that it doesn't make sense. Why should Singer be making plans to eat at Brannon's café when he has just moved into a boarding house where, as is verified later in the story, they serve meals?

In terms of the theme, Singer's presenting Brannon with the list (of food he wants served) is symbolic (in terms of Singer's role in the allegory and parable) of his asking if Brannon, as the common man, will serve him (that is, church and government), and that is the central question of the allegorical and parabolic themes. As to why Singer should ask this question, when he has meals available, the answer is that there is no answer—which is, paradoxically, the answer. It is not known whether the common man will serve church and state, even at the end of the novel or in the succeeding ones. This is the principal thematic question which the saga explores.

Brannon has not generally been considered the main character, but a comparison of him with the others tends to confirm it, and the original title of this work suggests that such a comparison be made. The word "mute" implies a handicap, and "the mute" can mean one

or many handicapped. In this novel, in addition to those who are unable to speak, there are some who can but don't and others who do but ineffectively (in terms of solving the problems of the South), and McCullers has indicated the nature of the handicaps to demonstrate who is which. Each of the four main characters has both a physical handicap and a mental, emotional, or other, abstract (and symbolic) one. Dr. Copeland is black, a minority figure who in 1939 is ineffectual in the South among a white majority. He also has a lung problem, difficulty in making others understand him.

Blount is an itinerant worker, with no permanent address, and therefore under law cannot vote. His other flaw is that he is too "blunt." His solution to problems in the South is to throw out the whole government because it is "built on a foundation of black lies."

Mick is an adolescent, which means that she is not old enough to vote, but she has another problem too. It is a psychological problem related to being socially acceptable: she is "too tall," by others' standards and, despite her protests that she wants to be different, she gradually becomes a total conformist.

Ironically, Brannon is the character who actually seems to be a conformist. He has a reasonably good job, is married to a Sunday School teacher, is sentimental about old songs, collects old newspapers, and has no burning desire to change the world. In fact, he operates a segregated café. He is portrayed as about as average as you can get, but that is exactly the point. He is the common man, and in American fiction that generally means he is the hero.

Like the other characters, Brannon has two "handicaps." He is impotent and he is effeminate. After his wife dies, he decorates his room with bright colors, wears her perfume, and even sews his own clothes. In the thirties this kind of behavior in a man was considered an indication of homosexuality, and indeed, a number of critics have assumed that this was what McCullers intended to imply. But I don't think so. In fact, it suggests that he is a nonconformist who is not afraid that doing "woman's work" constitutes a threat to his manhood. It is a sign of his strength. And since he was only impotent

around his wife (who was a conformist) he is free to act as he pleases after she is gone. So Brannon's apparent "handicaps" are paradoxically his strengths, and although he does not change the South of his day, it must be remembered that The Heart is a Lonely Hunter is realistic, and the South did not change in 1939. But unlike the others, who talk, Brannon listens. Unlike the others who act, he observes. And unlike his wife, who wants him to "get rid of the lunatic downstairs," Brannon likes "freaks"—and another word for freak is nonconformist.

In 1939 the only real political power in the South lay in the hands of the white male middle class. The novel suggests that in McCullers's opinion, the voting majority was not likely to change significantly in the foreseeable future, so it was important for the individuals who comprised that majority to change, as Brannon did, after his conformist, insensitive, wife died.

Like the parable, which depicts a bleak period in southern American history, the religious allegory evokes a bleak period in the history of western civilization, the Babylonian captivity.

Similarities between Israelite and southern American history during the formative periods of these "nations" are striking.[4] Both the people of Israel and the American colonists were unified under law with the Ark of the Covenant on the one hand and the Constitution of the United States on the other. After a brief period of exultation over having arrived at "the promised land," specifically Jerusalem and a federal union respectively, the tribes of Israel, like the American states, drifted apart. Initially the reasons were essentially economic, but over time, ideological differences widened the distance between northern groups and southern ones in both nations. The northern tribes, like America's northern states, were effectively unified in the amphictyonic tradition, their bonds with the Covenant and the Constitution, respectively, remaining strong. The southern tribes, however, like the southern states, succumbed to charismatic leadership, that of David in Jerusalem and that of the plantation system in the American South. Breaking faith with their

covenants, the southern Israelites established a corvée, and the southern states promoted slavery. Eventually civil war ravaged both nations, and while the northern tribes (of Israel) and northern states (of America) were involved, they remained fairly stable after the wars ceased. The southern tribes, on the other hand, were taken captive and sent to Babylon. The people of the southern states were not bodily removed from their homeland, but were psychologically perhaps even further alienated from the North than they had been before.

The parallels reflect the focus of McCullers's theme: divisiveness and the need for unity, both politically and under God.

The focus of the religious allegory in <u>The Heart is a Lonely Hunter</u> is on the plight of the people in captivity in Babylon as it seems similar to that of the people of the South during the 1930's. Both were, in effect, in a sort of limbo, for while in each case they were theoretically still committed to national union under God, in actuality they were estranged. In Babylon, the tribes began to doubt their God, for they reasoned that if He were all-powerful, He might have prevented their capture. Instead, He seemed to have abandoned them. Similarly, in the South (in the novel) Mick announces that she does not believe in God, and Portia searches for a God that seems to have disappeared.

In the epiphanal crossword puzzle in <u>Heart</u>, the words which allude to the Babylonian Exile refer both to the prophets and to an eventual end to the desolation of this period (Exodus). Historically, there are two prophets associated with the Exile, and their identities (as represented in the novel) are suggested by allusion, image, and symbol.

Jeremiah provided the exiles with a new perspective on their plight, helping shape their despair into hope and their doubt into conviction. Copeland's attempts to forge hope in his people through conveying to them his "strong true purpose" evokes the idea, and he was effective, as (symbolically) they named their children after him, suggesting that the future might be better.

Ironically, the dissolute Blount in the novel is evocative of the voice of Moses. The whiskey he drinks is symbolic of the (spiritual) fire which is an image of the spirit of the true God. Like Moses, Blount "knows" the Truth and would lead the people of the South out of their moral wilderness, but as the spirit of Moses is remote from the captive people in Babylon, the message Blount delivers is lost on the people in the South. He is, as he says, "a stranger in a strange land." Frustrated, he beats his fists against the wall (of ignorance) while "twelve onlookers and a few whores" stand by and watch.

Yahweh is the God of Justice, and that is Blount's theme song, but the Israelite captives were not at the time concerned with Mosaic law, and the people of the South (in the story) were not concerned with the word of God. The Israelites hoped vaguely for redemption; the Southerners yearned for something, but as Mick repeatedly said, "This thing I want, I know not what."

A spirit of desolation persists throughout, and the novel appears to end inconclusively, but this is deceptive. A single detail in the last chapter (the radio) indicates a similarity between the final days of the Exile and the end of the Great Depression. In both, events of global proportion were imminent. Cyrus the Great was making plans to invade Babylon, and Hitler was beginning to carry out his plans to conquer the world, as was announced by the crisis voice on Brannon's radio.

At this point in the history of the Exile, a new prophet appeared to proclaim that Babylon's almost certain defeat at the hands of the Persian Empire was a part of Yahweh's plan to reunify Zion. At a point slightly later in American history, President Roosevelt would call on all the people of the United States to join in a fight to defend the Christian and political principles of democracy, and implicitly this would signify spiritual reunification between North and South. America did not enter the war until 1941, and Heart was published in 1940, so McCullers could not have known what Roosevelt would say about America's going to war. Furthermore, there was no

recognized prophet in the South prior to the war who was predicting that if war came it would effectively weaken southern isolationism. But there was a lot of speculation that if Hitler went too far, America would become involved, and it seems likely that McCullers would not only have agreed but have looked beyond the event to consider its effect on the South. At any rate, the novel seems to indicate that this is so, and that she, with her first book's publication, was the prophet.

As an author is a paradoxically known and unknown presence in a novel, the new prophetic voice in Babylon was known for his words, but was otherwise an enigmatic figure. Nameless, he would be called "the second Isaiah." There can be no question about the similarity between his vision and McCullers's. Both foresaw the impending global conflict of their times as a catalytic agent which would reunite the tribes/states in terms of their national commitments. Both also believed that the outcome of the conflicts would have profound consequences in terms of man's struggle for Divine Unity. As, according to the new prophet, an ultimate result would be that pagan elements would be gradually drawn into Yahweh's fold, so McCullers believed that what would later be called a "war for democracy" would ultimately result in an end to the "pagan" practices in the South (that is, those humiliations and atrocities due to racism). While the prophet's vision was openly articulated, McCullers's was implicit in the publication of her novel, wherein it can be perceived within the parameters of her theme and the evolutionary nature of its development. Support for this theory lies in the similarity between her definition of the force that would impel that evolution and the prophet's definition.

The "Second Isaiah" informed the Israelites that "if Yahweh is the great actor in events, if Cyrus is his political agent, the true instrument of his purpose is his servant Israel." In historical accounts, Yahweh's Servant is ambiguously defined as both an individual and a people (the Israelites). But his "mission" is "laboring unobtrusively but unremittingly, to bring Yahweh's law to the nations."[5]

The figure who represents Yahweh's Servant in <u>Heart</u> is Biff Brannon. He is at once "the common man" and "the individual." He is also unobtrusive. In fact, his participation in the events of the novel are so unobtrusive that when it was made into a movie, the director included Brannon in only two scenes for less than five minutes (in a two hour and twenty minute film). Yet in the novel, he is a constant presence, a part of the action, but little involved beyond watching and listening.

Even his individualism is unobtrusive. Mick declares she is different from others, but eventually conforms. Blount is typical of the outspoken political radical of the period, and Copeland is predictable as a voice for his cause.

Brannon's individuality is indicated in non-dramatic ways which associate him with both compassion and respect for life. He ignores his conventional wife's heartlessness and feeds the hungry whether he gets paid for it or not. His kindness extends even to the lowliest of God's creatures, as McCullers notes that he did not kill a bee in his room but carefully let it out the window.

And of course, living in an era when sex roles were polarized to the extent that deviation was publicly ostracized, Brannon is seen as not being afraid to do "womanly" chores. Recognizing the importance of this aspect of Brannon's character, Patricia Box commented that "only androgens are capable of experiencing the sexless love that can ultimately unite all of mankind and change the condition of humanity from isolation to community."[6]

"In Brannon," says Ihab Hassan, "we are asked to entertain an image of clumsy endurance, a will for right action which no excess of hate or suffering or disenchantment can wholly suspend."[7] As the prophet foretold of "a highway through a desert blossoming," Brannon, in the last scene of the novel, places a fresh bunch of flowers out for display in his silent and desolate café before he settles down "to await the morning sun."

So while the novel seems to end on a pessimistic note, with Singer and Antonapoulas dead, Mick, Copeland and Blount each

going their separate and desolate ways, and Brannon seemingly alone in an empty café, this image is deceptive. It is merely a reflection of how things stood in 1939, for the novel is realistic. The kind of church that Singer stood for at that time in the South was delineated clearly by the only character in the novel who attended, Portia, and she described it as an edifice where people got "a little singing and a little preaching," but which did not attract intellectuals like her father. The kind of government which Singer stood for was killing itself in terms of its failure to deal with an intransigent South which still maintained Jim Crow laws. With Antonapoulas's death from kidney disease, McCullers appears to have been suggesting that capitalism might expire from excess waste, and that democracy itself had (to all appearances, in the South) become defunct, but the spirit of God survived physical death, and so Antonapoulas's demise is not without hope.

The religious allegory counters the pessimism of the realistic and parabolic levels of development in this novel, for it suggests that the spirit of God in just one man can make a difference. Brannon is not alone in his café. There is a young black man asleep in the back room. Although Brannon still runs a segregated café, he has hired Louis, and given him charge of the counter out front—a responsible job. Jobs were what black men needed. Further, Brannon does not wake the young man up and make him go stand and earn his money when there are no customers there. He knows the difference between what Copeland calls "service and servitude" and demonstrates respect for this other man regardless of race. This small detail might seem insignificant if it were not for the fact that an inordinate amount of space toward the end of the novel involved an argument between Blount and Copeland as to how best the denial of civil rights for black people might be overcome. Copeland advocated education, and Blount saw the only possibility as a new form of government. But McCullers's whole rationale relative to race relations is that its greatest horror lies in the humiliation it causes, which is debilitating to the human spirit. This is clearly indicated in

the fourth work of the saga, as its plot indicates that the opposite of the square root of wonderful is humiliation. Brannon offers Louis an opportunity for self respect. This indicates the kind of change in the attitude of white men that would have to precede unity between black men and white, and it is with the gradual evolution of the mind of the South and the concomitant evolution of awareness of the republican principle and the "divine imperative" that McCullers is primarily concerned.

THE BALLAD OF THE SAD CAFÉ

"Proud, brave, honorable by its lights, courteous, personally generous, loyal, swift to act, often too swift, but signally effective, sometimes terrible, in its action—such is the South at its best."

–W. J. Cash in <u>The Mind of The South</u>

"Violence, intolerance, aversion and suspicion toward new ideas, an incapacity for analysis, an inclination to act from feeling rather than from thought, an exaggerated individualism and a too narrow concept of social responsibility, attachment to fictions and false values, above all too great attachment to racial values and a tendency to justify cruelty and injustice in the name of those values, sentimentality and a lack of realism——these have been its characteristic vices in the past."

–W. J. Cash in <u>The Mind of the South</u>

<u>The Ballad of The Sad Café</u> is the strange tale of love between a woman and a dwarf, which is complicated by the dwarf's deserting her for another man who happens to be her ex-husband. Readers generally agree that the theme is the pathos of love and loneliness, but there is something especially powerful about its quality in this novel. Evans explains: McCullers has, he says, created "a parable of love" which, in defining "the eternal flaw which exists in the

machinery of love" raises the level of pathos to tragic proportions.[1] The effect McCullers sought to create has thus been recognized, but the reason has not been identified. It lies within the parameters of the saga.

The intensity of the pathos in this work is due to the fact that the historic periods, both religious and political, with which it deals in its artistic design reflect some of the most emotionally charged events in the journey of man. The period covered by its religious allegory includes the establishment of the Ark of the Covenant and the creation of a new, free nation in Judah. The political parable evokes the beginning of a new nation at the time of the Declaration of Independence and the establishment of the Constitution. These events are charged with the greatest love on earth: the love of freedom. But the allegory continues through the fall of the City of David and the parable ends with the failure to reunite the northern and southern states after the Civil war. Thus the full force of the pathos in this novel is due to its reflecting the desolation of entire nations as the joy associated with the love of God and freedom reflected in the Covenant and the Constitution was followed historically by a period of disillusionment.

That force is made palpable by a single character in the novel whose presence has been virtually ignored: the narrator. The tragedy of the human spirit as a result of the failure of man's dreams is conveyed in the form of one man whose legacy that failure is. To emphasize the pathos of that tragedy McCullers provided a perspective on it by showing its result in a single individual whose very position outside the action of the story exacerbates the sense of desolation associated with him. The real tragedy is demonstrated by the story's frame.

In contrast to the dozen pages McCullers devoted to indicating her "broad principle theme" by clarifying the symbolic roles of Singer and Antonapoulas in her first novel, only four pages comprise the frame of <u>Ballad</u> to serve the same purpose. In these pages she defines

the time, the place, and the character of the narrator whose point of view will shape the story he tells.

This narrator speaks from a small town in the deep South. Georgia is indicated by the mention of a few peach trees lining the main street. The town is a mill town, surrounded by tenant farms, and its main street is only "a hundred yards long." This place is "dreary," with the only excitement provided by the farmers coming to town on a Saturday, and even this event seems to have lost some of its flair, for the big house at the end of the street (which we learn later is the country store, or place of gathering) is closed down and boarded up. This detail seems to suggest that the time is after cars have come into general use because the Saturday gatherings of farmers at the store during the horse and buggy days were due to the need for people to rest and socialize a little (and let their horses rest) before starting the long, slow ride home. The matter seems confirmed by the narrator's remark that people are trying to figure out what to do with their old wagon wheels. The time is more specifically indicated by the narrator's comment that "there is no good liquor to be bought in the town," which suggests prohibition, or the twenties. It also suggests an everyday, dull existence without "spirit." Finally, it is a time when the chain gang was such a prominent part of the southern American scene that you didn't have to walk more than three miles to see one. From these details, it appears that the setting is a small town in Georgia some time around the late 1920's or early 1930's.

The action which takes place in the frame consists of nothing except the narrator's walking around in the town and a few miles down the road, and the time it takes for him to tell his story is less than a whole afternoon. Thus in terms of the narrative level of development of the saga, the realistic time of this novel is only a few hours on an August afternoon in, say, 1929, about ten years before the narrative time of <u>The Heart Is a Lonely Hunter</u> begins, and just as the Depression set in.

The narrator is the main character in the sense that it is his mind with which McCullers is chiefly concerned. In the first two pages of the frame, the tragedy of that segment of the twentieth century South which he represents is conveyed. He not only considers his little world dreary, but has neither idea nor imagination as to how to enliven it, for as he says, "when your shift is finished, there is absolutely nothing to do; you might as well walk down to the Forks Falls Road and listen to the chain gang." His "soul rots with boredom." The sight of the big house at the end of the street prompts him to think about what it used to represent, and so as he walks down the road, he muses on what he remembers about it, and this constitutes the ballad, or story he tells. Thus the entire portion of the novel which deals with the café, the woman, and the love triangle exists only in his mind, and is shaped by it. It represents his memory of the past. Or rather, it represents what he has come to know about it, and in a sense, what he knows represents what just about everybody in the South in the early part of the twentieth century knew because the South clung to the image of its glorious past right up until World War II. Confederate flags still flew, old Confederate soldiers sat around telling tales, their wives, children and grandchildren sat listening, and it was great and glorious to hear these stories, and feel a part of something that had been so grand. It was especially wonderful to think about the past since the present was so desolate.

Remarkably, the events which the narrator of McCullers's story "remembers" include many details which demonstrate that the events made a strong impression on him. His memory is so good, in fact, that it is clear that somewhere in his subconscious there is considerable knowledge of southern history. Yet after having gone all over this history in his mind (as he tells the story to himself) for what appears to be several hours, and in spite of the fact that (within the context of McCullers's dual theme and tripartite development) what he remembers is essentially a history of what might be considered the highest and perhaps the lowest points of the spiritual

and political history of the western world, the narrator can see nothing in it at all which relates to him. All he can think to do, in the last part of the frame, is to "walk around the millpond" or "stand kicking at a rotten stump." This is the heart of the pathos of the tragedy of this novel. It is not the momentary trials and tribulations of worldly love such as are seen in the story of the characters who dominate the stage of the narrator's memory that ultimately matter; it is the pathos of the human condition as it is demonstrated by the narrator. When, like the narrator, man is sufficiently aware of the meaning of Divine Love and political freedom that he can, in thought, relate the two and perceive the joy they have brought to the world in the past but still cannot comprehend how they relate to him, then his situation is truly tragic.

Ironically, one of his own comments in the story makes McCullers's point: "the value of any love is determined solely by the lover himself." As is shown in the last two pages of the frame, this (presumed) lover of God and country has learned nothing from all that he knows and has reviewed in his mind, for when he looks at the chain gang, he shows no compassion for the men nor does it occur to him that for men to be chained together in a free country "under God" is an affront to both religious and political commitments.

The tragedy of this character is further indicated by the title of the novel. A ballad is a song, yet he does not sing; in fact he does not even relate what he knows to anyone else. It merely exists in his memory. Also, like the coda, which suggests that he does not think about what he sees, the title indicates that he does not think about what he knows, for his story is not about a sad café at all. It is about a house which is sad only when it is not a café.

In many ways The Ballad of the Sad Café resembles Faulkner's story, "A Rose for Emily," with which it has been compared.[2] In both, there is a narrator whose function is complex, and in both, his "story" is an allegory of the southern past. In each, the woman who lives alone in the big house on main street is a symbol of both the

aristocratic values of the old South and the isolationism and separatism which remained a strong force in the region in the early twentieth century.

But the differences between the two works are far more numerous than the similarities, for, of course, Ballad is a novel, and Faulkner's "Rose" was a short story. Faulkner's house in "A Rose for Emily" dates from the late nineteenth century; McCullers's house in Ballad dates back to 1776. Faulkner's characters are symbols; McCullers's characters play dual symbolic roles. The manipulation of time in both authors' works is the same except that in Ballad the references to time past are seeded with allusions to specific times, dates, and historic events.

Miss Amelia's house is a metaphor for the past, what Hawthorne might have called "the paternal edifice." On the narrative and parabolic levels, it represents the social, political, cultural and moral milieu of the South during the century following the establishment of the Republic, and continuing through the first decades of the twentieth century. Its furnishings suggest different periods within this time frame. The big bedroom is equipped with a four-poster bed which suggests colonial and/or plantation life. Miss Amelia's room, however, is so bare that she does not even have a wardrobe closet; she hangs her clothes on a nail, as a frontiersman or farmer might. The third room on the upstairs level is a parlor containing a curio cabinet, a Victorian appurtenance. The downstairs has a big room which is combination country store and café, and there is a small room adjoining it which has a typewriter in it, which serves as a business and doctor's office.

Miss Amelia, who lives in this house, is a composite of many aspects of the southern mystique. Living regally in the big house, flaunting convention, supervising her cotton fields and scandalizing the town folk with her capricious ways, she is an image of the plantation lord. She also represents a burlesque of him with her penchant for lawsuits and her paternalistic attitude toward the common people. Another side of her, though, is composite of

cavalier, frontiersman, yeoman, and even the rising middle class. Her frontier-like independence is seen in her swaggering and in her confident assays into the deep woods where her still for making whiskey is found. Overalls are her sartorial preference, and she eats with "the relish of a farm hand" and with his flair for the abundantly-laid table as well. The private rooms in her house are "immaculately clean" and her parlor is "elaborate," reflecting both the fastidiousness of plantation and farm living and the decorum and propensity for ornamentation of the Victorian era. Yet she is a hard-nosed businessman, and country doctor too, with her office full of mortgages and herbal remedies. In short, Miss Amelia is a composite of the better impulses of the South. She is a giant (the narrator sees her as being six-foot-two) because she represents the forces which made the South strong during this period. She is a giant because the narrator's pride in those aspects of his heritage she represents swell his image of her in his memory. And she is a woman because in the "old South" women were seen as the guardians of principles held (ideally) most dear.

Her counterpart is Marvin Macy, who represents the baser elements of the South. He comes from a large family, in the tradition of poor Whites in the South. The family is plagued by disease; only he and one brother have survived. He is a swaggering, guitar-playing fellow whose arrogance attracts the foolish adoration of young girls, whom he then cruelly casts aside. He has no taste, either aesthetic or gastronomical: his idea of a wedding gift is some chitterlings (hog intestines) and "a pink enamel doreen of the sort that was then in fashion." He is also a member of the Ku Klux Klan.

The brief courtship and marriage between Macy and Miss Amelia illustrates the strange love-hate relationship that existed between southern social classes of the period. This marriage also provides us with a date which is important in identifying the elements of the political parable.

The parable develops by way of events that are evoked by image and allusion to well known symbols. The first event is the

establishment of the Republic, which is shown as a good portent in the opening paragraph of the narrator's tale, when he describes the paternal edifice as a bountiful storehouse of goods. The second event marks the beginning of southern separatism. This event looms so largely in the narrator's mind that it constitutes an important event in the dramatic action. This is the courtship and marriage of Marvin Macy and Miss Amelia. It is said in the story that this marriage took place when Miss Amelia was nineteen years old, and she is thirty when Cousin Lymon appears in 1865, so that would make the date of the marriage 1854. The date has a special meaning in terms of southern history, for it is the year that the Kansas-Nebraska Act was passed, and the gist of this was that all new states would be allowed to decide for themselves whether or not they would permit slavery. The passage of this legislation was undoubtedly due to many factors, but from McCullers's point of view, it represented a victory for those who promoted the economic expediency of slavery over those in the South who had moral reservations about the system. In the dramatic episode in the novel which deals with this symbolic development, Miss Amelia is shown to be somewhat reluctant to even walk beside her new husband, much less share her personal life with him (and thus McCullers dramatizes these reservations). But the historical effect of this Act was to expand the slave-holding territory, and this is why, in the story, Macy's entire approach to the marriage is described in terms of the gifts he brings to Miss Amelia, and this is why, too, he gives her a fortune in timber and land.

The next event in chronological historical order is the Civil War, which in the story is actually a non-event, marked only in terms of its conclusion, for the narrator is a Southerner, and his mind does not dwell on the humiliating defeat the South suffered in battle, but rather on the victorious home-coming of the valiant Confederate soldiers. McCullers is not interested in the war; she is concerned only about its effects on the minds of the people. Her aim is to explore the forces that would shape the region in the years to come.

The next event of the parabolic level is the brief period following the war in which, in the narrative plot, the café is established and which, in the historical time frame, represents a time when the possibility of ideological unity between North and South seemed possible: the four years between the end of the war and the beginning of Reconstruction.

Reconstruction is indicated by the return of Marvin Macy, who represents southern scalawags who cooperated with northern carpetbaggers during that period. He also represents the spread of cotton mills across the region, for it is said that when he came, he brought the snow. He is greeted with hatred by Miss Amelia. They finally fight with each other over who will dominate the South, and he wins. The sequence of events is over. The baser elements of the South will govern the region for a long time to come.

A number of readers have commented about the "two distinctly different narrative voices" in this novel.[3] The stylistic difference is a device to emphasize the fact that the story is not real, but exists only in memory. This is important because memory has a way of playing tricks. One trick it plays is that the narrator clearly remembers a character who played a prominent part in the past but who does not actually exist except as an idea. His name is Cousin Lymon Willis.

Lymon is very strange. He appears out of nowhere, but is soon parading around as if he owns Miss Amelia's house. She adores him though he is an unattractive and unresponsive lover. He has a hypnotic effect on the locals of the town as well, though for no particularly observable reason. His personal appearance is ridiculous. He is a humpbacked dwarf who wears high-topped boots and a green shawl, and his ears are so large that he is able to flap them back and forth. Near the end of the story, he is said to leap nearly twelve feet across the room. In short, he is too curious to represent a real person or even a composite of real people.

But he is as real as an idea is real, and one clue to his symbolic identity lies in the fact that he is a dwarf. In McCullers's fiction, as Jake Blount (in her first novel) said, there is always "another meaning

to the word." A dwarf is a pixie, which rhymes with Dixie, and while a dwarf is associated with distortion, a pixie is a little spirit. Cousin Lymon is a pixie who is a symbol of the spirit of the South, which is known as Dixie.

The time, the date, and the narrator's description of his arrival confirm this conclusion. The song called "Dixie" was written in 1859, and became the rallying cry of southern soldiers during the Civil War. It represented both an incentive to fight and the dream of homecoming to rebel soldiers. Lymon arrives "home" (that is at Miss Amelia's) late at night, walking alone down a dusty road (an image of the way Confederate soldiers' homecoming is often portrayed in the movies). His arrival is in April, the month the war ended, and it is described in a passage which is distinguished by its lyricism, a stylistic departure from McCullers's usual narrative and always signifying that what is described exists in the imagination, or in a dream. It represents the narrator's mental image of the pre-war South, thus associating him with the song that reflects the dream of restoring the region to what it had used to be: "Dixie."

But Lymon stands for more than a song, for in McCullers's fiction nothing is that simple. The governing principle in development of theme in her saga is dualism (i.e., religious and political), so like Singer and Antonapoulas in her first novel, Lymon is both symbol and image and has a dual role. And just as McCullers defined the multiple symbolism of the two mutes when they were first introduced, she defines Lymon's roles as soon as he enters the story. In the process, she delivers information which establishes the historically-based chronology of the story, and indicates its thematic intent.

When he arrives at Miss Amelia's door, he claims to be kin to her, and in response to being questioned about this, he gives a long recital of his lineage. The allusions within his discourse are clues to his double symbolic identity and hers.

His mother and Miss Amelia's, he says, were half sisters. Their names were Fanny and Martha Jesup. The name Fanny is an allusion

to Fanuille Hall (in Boston) which is known as the "Cradle of Liberty." The name Martha alludes to the wife of the first American president. The implication is that Lymon and Miss Amelia are both related to the beginnings of the American Republic, and associated with the spirit of independence and freedom. But the fact that Lymon mentioned that their mothers were half sisters is important, and the reason becomes clear as his story continues and emphasizes the year 1835.

As Lymon's story proceeds, he informs us that his mother left Cheehaw, the town where both Fanny and Martha had lived, "some thirty years ago," which would place the time of her departure at 1835. This is coincidentally the same year that Miss Amelia was born, so the date is important. Lymon calls the town Cheehaw, but McCullers is simply playing on the name Waxhaw, a town near Charlotte, North Carolina, where McCullers lived when she was working on her first novel. Waxhaw is well known as Andrew Jackson's home. Miss Amelia remembers that she "had a great aunt who owned the livery stable in Cheehaw," but it was Andrew Jackson who owned a livery stable in Waxhaw. Lymon's favorite amusement is cock-fighting, and Jackson is said to have had a penchant for this "entertainment." This tells us that Lymon had, at one time, something in common with Jackson. We next learn what it was: it was Jackson's commitment to freedom, as indicated by Jackson in his inaugural address. In that address, in 1829, Jackson had declared that "The Federal Constitution must be obeyed . . . and the Federal Union preserved." As a symbol of the spirit of American freedom, Lymon loved freedom as much as Jackson claimed he did—and that love was strong enough to fight for, as Jackson indicated in the strength of his address. The connection between this address and the cock fighting is that a cock is a bird, and the symbol of American freedom is also a bird—an eagle. This is one example of how McCullers uses her language design (through all her works), and as will be seen, this particular use of it is confirmed in this story as it is

part of an identifiable design within this novel (which will be discussed later).

But Jackson betrayed the national ideal in favor of states' rights, and this was the birth of separatist southern power. In 1835, the Cherokee Indians were forced to flee from Georgia (McCullers's home state) with federal troops in hot pursuit, and this event marked the culmination of a lengthy court battle over the civil rights of individuals in which Andrew Jackson took the side of states' rights against federal law. Since Miss Amelia was born in the same year, the point is that she represents the southern distortion of the American Dream.

So within the context of Lymon's lineage, both his and Miss Amelia's symbolic identities relative to McCullers's theme are revealed. Their mutual heritage is national unity, or the establishment of American democracy, except that he represents the spirit of freedom and she is associated with politics through her "father" (George), the builder of the "paternal edifice" which she occupies. Her heritage is thus in the tradition of American freedom. However, she also represents the "new" South as it evolved between the time she was born and the time of the Civil War. She was born in 1835, in Cheehaw, so her birth date and place (Waxhaw) coincide with and are associated with the birth of southern separatism (as represented by Andrew Jackson). Lymon, who was initially associated with the American Declaration of Independence (as Fanny's child) continues to symbolize the spirit of American freedom, but he represents the spirit of southern independence as well by virtue of his Cheehaw heritage and kinship with his cousin Miss Amelia. This explains why he is humpbacked. He carries the weight of the southern perception of freedom (i.e., freedom only for Whites) on his shoulders, and this perception is a distortion of the original ideal. This explains why the more southern vittles Miss Amelia feeds him, the more disfigured he gets.

This also explains why, in the title of the novel, the café is "sad." As an image of the spirit of freedom, Lymon turns the store into a

café, and according to the narrator, the two requirements for a "proper café" are that it have an "air of freedom" and that it be a place were people are accorded respect. This café is not sad. It is in the South, and materializes immediately after the Civil War ends, when it was briefly (for four years) possible that the South might subscribe to national ideals. When it is clear that this will not be the case, the café no longer exists, and that is what is sad. The title of the book is ironic.

The return of Marvin Macy signals the end of the café and the beginning of Reconstruction. A battle ensues between Macy and Miss Amelia as to which of them will control Dixie. Macy, representing the forces of mediocrity now strong and getting stronger in an increasingly industrialized South walks off with the prize, as the symbol of national power walks away with him. Miss Amelia, like Faulkner's Miss Emily, remains as a symbol of the "old South," but her influence in terms of representing the force of decency, industry, education, etc., is gone.

McCullers's story differs from Faulkner's story, "A Rose for Emily," though, in an important way. The town Miss Emily lived in was actually set in the 1920's, but Miss Amelia's town is described as "a place that is far off."

This term is strikingly similar to the definition in Brannon's puzzle ("a six letter word meaning to remove afar off"). The major difference is in the phrase "to remove." Our answers to that puzzle were "exiles" "Exodus" "Elijah" and "Elisha," but the definition called for a lower case "e" and the book dealt with the Babylonian exiles, not with an exodus. So the correct first answer was "exiles." Now in the second novel of the saga we have a similar definition without the words "to remove." In McCullers's work, it is often true that what is missing is what is needed. I submit that the author intends for us to make a connection between the two novels because of the similarity in phraseology. The word "Exodus" and the two prophets, Elijah and Elisha, are associated (in <u>The Heart Is a Lonely Hunter</u>) with a period preceding the Babylonian captivity (which that novel

deals with). But <u>Ballad</u> precedes the first novel in historical chronology. In fact, the Exodus out of Egypt is indicated, and that is where the religious allegory of <u>The Ballad of the Sad Café</u> begins.

The religious allegory is developed imagistically, and the first image associated with it is Miss Amelia's whiskey. It is introduced immediately following Lymon's recital of his genealogy, and its significance is manifest in several ways. First, it is very select. It is made way back in the swamp, and no one in the town knows exactly where. Secondly, it is exclusive. The narrator says that it is a rare thing for Miss Amelia to give a drop of it away free, and the townspeople are astounded because she is giving it to a stranger. Moreover, that stranger is said to remind them of a Jew who formerly lived in the town, one Morris Feinstein. Finally, this whiskey is said to have "a special quality of its own."

> "It is known that if a message is written with lemon juice on a clean sheet of paper there will be no sign of it. But if the paper is held to the fire, then the letters turn brown and the meaning becomes clear. Imagine that the whiskey is the fire and that the message is that which is known only in the soul of man—then the worth of Miss Amelia's liquor can be understood."

This appears to associate the whiskey with the God of fire as he appeared to Moses on Mount Sinai to give him the words of the Covenant. Since all symbols in McCullers's development of the religious and political progressions are dual in that they relate to both, this whiskey also alludes to the fire of the spirit of independence which led to the words of the Constitution of the United States. McCullers is careful to say that they drank "two big bottles of it."

The religious allegory equates the early history of the Israelites with the early history of the southern United States. Solomon founded the empire of Israel, but during his son's reign, the nation began to split. Similarly, Miss Amelia's father was a founding father of America, but his daughter's birth symbolically signaled the

beginning of southern separatism. Solomon's son David rejected the amphictyonic tradition and permitted slavery, which was incompatible with Covenant law. Miss Amelia (the South) split with the North and allowed Macy (associated with racism) into her house in violation of the national Constitutional ideal. Both the city of David and the Confederate states prospered briefly but began to develop class structures which gave rise to tension and unrest.

The Davidic state erected temples which some scholars believe were intended for worship of Yahweh, but which were architecturally designed in such a way that their icons resembled other gods, causing unthinking people to be confused and effectively idolatrous. In Ballad a café is created, causing the people to believe it is "a proper café" (café being a symbol of unity and the spirit of freedom) but this is a false impression, for it was begun as a result of what the narrator alludes to as an "unholy alliance" between Cousin Lymon and Miss Amelia. Both of them, in their southern roles, represent limited freedom (available only to Whites). Later, during the fight between Macy and Miss Amelia, in the café, Lymon suddenly "sprang forward and sailed through the air as though he had grown hawk wings." Moving twelve feet through the air, he landed on "the broad strong back of Miss Amelia and clutched at her neck with his clawed little fingers." The description seems to be an allusion to the icons which had caused confusion in Jerusalem. The temples which David had erected to the worship of Yahweh were flanked by winged sphinxes. Lymon flies like a winged creature, landing on Miss Amelia's back to create a sphinx-like image.

Janice Moore has noted that in this novel there is a consistent pattern of imagery which projects Lymon as one sort of bird or another. According to her, Lymon is first likened to a sparrow, later to a magpie, and finally to a hawk. She concludes that his transformation indicates his "propensity toward evil,"[4] and this would seem to confirm my interpretation. In the religious allegory, Lymon's bird-like flight is, like the sphinxes in Jerusalem, representative of the evil of deception. On the level of the political parable, Lymon

resembles (at this point) a hawk, and not the eagle which is the emblem of unity and freedom in America. In his flight, Lymon betrayed these forces—just as the Constitution betrayed the concept of freedom by its exclusion of Blacks.

Lymon's appearing to represent deceptiveness is part of his role as a central symbolic figure in the novel. He represents a paradox, for he is a symbol of both unity and disunity. But this is a major focus in McCullers's linearly developed design, for she explores the paradoxical nature of man, who theoretically and intellectually subscribes to principles of unity in moral and political ways, but who in practice supports divisiveness.

It must be remembered that semantic ambiguity is a major device in McCullers's work, but that in her paradigm associated with language, she uses almost every device possible. Cousin Lymon represents both unity and disunity. Therefore, his name is Lymon, which in McCullers's characteristic manipulation of the language, translates to "lying man." He created what appeared to be a "proper café" but this was deceptive; it didn't last because it was based on the appearance of the spirit of freedom, but in representing Dixie, Lymon represents a distortion of the national ideal. The southern idea which he represents is Dixie, symbol of a slave-holding region where white supremacy still reigns. Freedom there is restricted to Whites.

Lymon is the little pixie's Christian name, which suggests that he is also a symbol of deception within his imagistic role as the spirit of God in the religious allegory, and this is borne out in the novel as he shows no love for Miss Amelia, no compassion for her suffering, and no remorse when he vandalizes her kitchen and runs off with Marvin Macy.

Yet his power is great because part of his symbolism is pure. With his little high-topped revolutionary war style boots, he is a symbol of the spirit of American independence and unity; and it is only within the scope of his being kin to Miss Amelia that he is seen as a southern distortion of that spirit. Similarly, it is only within the

parameters of his association with man that his ideal spiritual image has become distorted. Man gave him his first name (Lymon); God gave him his last name (in the sense that through God's grace he was born into the Willis family) and the name "Willis," when split, equals two words, "will" and "is." These two words link him to the Mosaic God, Yahweh, whose name is "a causative form of the verb 'to be.'" They also link him to the Christian God, who is known through the present tense of the verb "to be" i.e., "I am." In other words, while he represents worldly prostitution of religious and political idealism in the date and time of this novel, the spirit which he represents will not expire in the world of men despite its devious rambling because (as McCullers indicates) while he seems misguided in this novel, he is, at the end of the story, alive and kicking somewhere.

Similarly, as Robert Phillips has noted, "the name Amelia . . . derives from meliorism, the doctrine holding that the world may be better by human effort."[5] Meliorism may also be defined in terms of "becoming" which is a participle derived from the verb "to be" (and which also thus associates her with Yahweh, for the name "Yahweh" means "to become"). She, too, is still alive at the end of the story, and right at the end of Main Street, which suggests that what she stands for may have been subdued but is far from gone. Her grey crossed eyes will, figuratively, simply need to straighten out. Eyes are a symbol of point of view of a character throughout the saga. Amelia's, of course, which are gray and crossed, suggest the Confederate flag.

Evolution is at the heart of the saga's development, and it involves not only the historical shifts shown in allegory and parable but the shifting perspectives of individuals on the narrative level as well, and the focus of this level of development in terms of the saga is on the civil rights of minorities.

There are, in The Ballad of the Sad Café, almost no women. When the café is formed, a few men bring their wives to it on a Saturday night. They are said to be "guests" of their husbands. Miss

Amelia is female, to be sure, but she is a symbol of power, and power was in the hands of men during the nineteenth century, so she is built like a man, dresses like a man, and acts and talks like one. In fact, the irony of the situation is that she looms so large and masculine that her very presence calls attention to the absence of other women in the story. There is one mother mentioned, and even she (like the others) is not named.

Indians are not mentioned because the narrator does not care about the Indian. The novel's allusion to Andrew Jackson (who forced the Indians out of Georgia) makes McCullers's point: from the point of view of a white millworker-narrator existing in 1929, the Indian "problem" had been taken care of. By 1929, Indians were not a minority; since they were no longer a threat, they were a memory, a reminder of the white man's power in subduing them.

McCullers's main concern was the black man, and in this novel she delineated his plight as the narrator saw it—which means that it is barely perceptible in the text because the narrator is a 1920's mill worker, who does not think about black people except as incidental. The narrator mentions them in three ways—as they have meaning for him. First, they are alluded to in the lyric passage describing the night Lymon first came down the road. In this passage, the Negro is said to be lazily ambling through dark fields in the moonlight, on his way to make love. It is a white person's romantic view of Blacks as they appeared to him during the period of slavery, prior to the Civil War. The next reference is to how they were seen after the Civil War, as people who were not important enough to have names and identities, but who existed only to serve Whites. This reference is to Miss Amelia's servant, Jeff, who is always present and working in the café, but whose presence is totally ignored. He has no last name, no identity other than being a pair of hands, no voice, and no "presence" in the story. He is such a non-person to the narrator that his name is mentioned only once, and so unobtrusively that it has apparently not even been noticed by readers. The third way the narrator sees black people is the way they appear to him, personally:

as criminals. This is indicated in the Coda, which is set in 1929. Here the black man is seen by such persons as the narrator as a convict, happily singing while he's on the chain gang. These three images reflect the shifting impressions of black people by the "average" white Southerner over the time periods indicated. The average white Southerner in the 1920's had roughly a fifth grade education.

The number of views held by Whites toward Blacks presented to us in this novel is important because the number three is important in McCullers's mathematical paradigm, for it represents worldly limitation, and in terms of this novel, the three views of Blacks demonstrate the need for one more, one which indicates white acceptance of them as equals.

The number ten, on the other hand, is the perfect number because it represents both unity and completion. This number does not appear in the text of any other of McCullers's major works, but ironically it does in <u>Ballad</u>.

When the townspeople don't see the dwarf for a day of two after his arrival, they think he may have been murdered, so eight townspeople gather on the porch of the store. Cousin Lymon opens the door and lets them in, which makes nine. When Miss Amelia comes out of her office to join them, the number of people brought together has reached the supposedly perfect number ten, and the fact is emphasized in the novel because it is said that this happens at exactly ten o'clock. The magic of this number is thus associated with the beginning of the café, the symbol of respect for others. But the café is not what it appears to be, for Lymon is not what he appears to be (he is, in part, the southern concept of freedom). Furthermore, the number ten is derived by the formula eight plus two (when the ideal formula is three plus one). And finally, the number of people in the café on this festive evening is not ten. Ten is only the number of people the white people see. There are eleven, for the black servant is there to serve, but not considered a person by the others. Moreover, Marvin Macy is not there—and for true

freedom to exist, the Whites he represents must participate in creating unity.

Another way to perceive this situation in terms of McCullers's formula is that three entities were named as participants in the café interlude: the townspeople, Cousin Lymon, and Miss Amelia. Two individuals constituted a possible fourth: the servant and Macy. The black servant's presence (if acknowledged and respected by the white participants) would indicate equality (under law). Macy's would indicate southern white commitment to legal equality. The formula is 3+1. It is distorted here because there are two missing "ones." Black and white should "speak" as one (in unison).

The 3+1 formula appears in many ways. There are three "good people" in the town, three boys "from society city" and three main characters in the story's drama. The number seems to be associated with goodness, but actually, if there are only three "good people" in the town then the others must be bad. Similarly, "society city" sounds like a more advanced place than the town of the story, but since only boys are mentioned, McCullers seems to imply that girls have little social standing in society. Finally, the three main characters are in continual conflict with each other. So the number three, in these configurations is associated (paradoxically) with badness in terms of its implications. As MacDonald has suggested, the number three represents suffering, so the impression that it is associated with good is deceptive. The three areas the sets of "threes" are associated with are the house, the town, and the region, which suggests that the suffering is pervasive. It also suggests that the addition of one more number might alleviate matters, for that one would represent national "goodness" and fulfill the formula, three plus one.

The number twelve has been shown to suggest a relationship between the five works of the saga: each one begins and ends with this number. The number twelve thus represents (paradoxically) completion and incompletion. One sequence is done. Another lies ahead. The journey toward racial equality occurs in stages. The Ballad of the Sad Café ends with a coda called "The Twelve Mortal

Men." This coda describes a chain gang composed of seven black men and five white men, and would seem to suggest racial unity. McCullers draws attention to this idea by describing the men's prison suits, which are black and white striped. But the suits are prison garb and indicate that the men are criminals, besides which they are being watched over by a guard with a gun who represents the law. So the coda is an image of the fact that in this place at this time, it is criminal for black and white men to work together as equals.

The number twelve of the coda also acts as an epiphany, directing attention to the linear development of the desire for Divine Unity and need for worldly unity. There were twelve tribes of Israel. There were eleven states in the Southern Confederacy, plus two which were split in terms of their political regional/national commitment, which equals eleven plus two halves, which equals twelve (and as the inquisitive reader will see, McCullers employs this sort of logic/image elsewhere). And there are twelve men on a jury. The coda points to the religious allegory, the political parable, and the narrative levels of the novel's development, from the viewpoint of one narrator. The epiphany points to the 3+1 formula.

As the narrator describes the chain gang, he seems momentarily to be inspired by their song. It begins with "one dark voice" which seems to him to ask "a question." It grows, or "swells until at last it seems that the sound does not come from the twelve men on the gang, but from the earth itself, or the wide sky. It is music that causes the heart to broaden and the listener to grow cold with ecstasy and fright."

The question the song "seems" to the narrator to ask (though he does not articulate it because he only vaguely feels it and does not know what the question is, which is part of his tragedy) is: when will harmony among men be achieved? The emphasis on music is an allusion to the importance of the artistic paradigm associated with music which is part of the artistic structure of McCullers's theme of need for worldly unity. In the final lines of the novel, McCullers asks, "what kind of gang is this that can make such music?" The narrator

does not know, but we do. It is a gang of black men and white working together. It is integration, another word for unity.

The music produced by the chain gang is just a sound. It is a song without words because it is a symbol of the status of man's progress in his eternal quest. In 1929 white men and black are chained together as criminals, but their souls yearn for freedom. Until they are chained together by mutual respect for each other, the voice of freedom will be mute.

THE MEMBER OF THE WEDDING

I sing because I'm happy,
I sing because I'm free,
For His eye is on the sparrow,
And I know He watches me.

Why should I feel discouraged?
Why should the shadows come?
Why should my heart be lonely,
Away from heaven and home?

For Jesus is my portion,
My constant friend is He,
For His eye is on the sparrow,
And I know He watches me.

– Hymn in the musical version of
<u>Member of the Wedding</u> . . . Ethel Waters

<u>The Member of the Wedding</u> is the story of a young girl named Frankie Addams, and of how the impending wedding of her older brother precipitates a crisis in her life. Readers generally agree that the main theme of this novel is adolescence,[1] and it is, but it is much more, for within the parameters of its religious allegory, it explores the turbulence of the formative years of western civilization's spiritual quest in the church's struggle for identity and stability, and on its parabolic level of development it conveys the adolescent period in

the American struggle for freedom as an image of commitment which has not yet politically matured. Most importantly, this novel focuses on the struggle of the individual to deal with these problems and to come to grips with himself in terms of his individual commitment and responsibility with respect to his political and spiritual ideals. In this sense, it shows progress toward the Dream.

Frankie Addams represents the "adolescent" stage of the South's growing awareness of its need to figuratively re-join the union by doing away with racial segregation and inequality. As the novel indicates, this small segment of the population was about as helpless in making this happen in 1943 as an adolescent would have been.

On the parable level, Frankie represents that segment of southern thought which, with the advent of World War II, saw hope that this national effort would result in an end to southern isolationism. Thrilled with her brother's participation in the war (which was hailed as a fight for democracy), Frankie wanted to help (by donating her blood to the cause) and felt the wedding indicated a union (symbolically) between North and South, so she wanted to be a part of that, too.

In the religious allegory, Frankie represents the true believer in the God of Abraham who is suddenly confronted with the coming of Christ, and becomes confused as to the direction his commitment should take. After making his decision, he is beset with frustration as the subsequent internal struggles within Christianity result in uncertainty and confusion.

The actual time of the narrative action is three days. The time of the parable is five years, and the time of the allegory is roughly seventeen hundred years. These time periods are indicated in the development of Parts I and II. The third Part is brief and temporally distant from the time of the main action by three months. It defines the effects of all three levels of development, and emphasizes McCullers's focus on the importance of individual understanding of and commitment to a power greater than he and a political force which will guarantee him freedom to express himself.

On the narrative level of the development of this novel, the dominant setting is a dreary kitchen which represents the narrow provincialism of the South as it existed prior to World War II and during the years of that conflict. There are three characters in this kitchen, and one of them is John Henry, who is a cousin of Frankie's and younger than she. He represents the segment of the white southern population which is descended (fictionally within McCullers's saga) from Marvin Macy and Mick Kelley (in the preceding two novels). Like Macy, he is irresponsible, disrespectful and dishonest: he cheats at cards, taunts Frankie when she is unhappy, and refuses to talk to her when she wants him to talk. His shaping of the dough man (which is exaggerated in the first section of Part I of the book) suggests his arrogance in his ability to manipulate others. Like Mick Kelley, he is a conformist. His idea of fun is playing in the streets with other children (which Frankie has now outgrown) and his perspective on things is distorted (which is indicated in the text when Frankie tells him his glasses do not really help him see). John Henry represents a segment of southern thought which poses a problem for those who would like to see change. He has defaced the environment (the kitchen) with his drawings, and is portrayed as a child who cannot participate in adult discussion of ideas.

Berenice is the second person associated with the kitchen, and she has a role of prominence second only to Frankie's in this story. The black maid for the Addams family, she is the literary descendant of Jeff in <u>The Ballad of the Sad Café</u> and of Portia in <u>The Heart Is a Lonely Hunter</u>, and the difference between them and her is dramatic. Unlike Portia, Berenice aspires to better herself, and has a strong personality. While her role as maid demonstrates that Blacks are still economically dependent on the white middle class family (for this job availability for black women was a dominant source of income for black people at the time) she is treated with respect by Frankie, who defers to her judgment, argues with her, criticizes her, and generally treats her as an equal. It never occurs to Frankie to mock

Berenice as Mick Kelley used to "devil Portia." Berenice is intelligent and self-reliant. She asserts authority over the children and challenges the law (as when Honey Brown is in trouble) and at the end of the story, she marries a businessman, which indicates that her social situation is improving. Her status represents progress in racial equality in the South.

Berenice, Frankie, and John Henry play bridge each afternoon in the kitchen, and this game is an image of their relationship as three aspects of southern society bidding for power. John Henry, whose double name identifies him with the rural, largely uneducated South, and whose young age suggests the immaturity of the segment of the southern population he represents, cheats at the game by removing cards from the deck so that nobody can win. Frankie knows he cheats, but lacks the maturity to stop him, and Berenice lacks the power because she is black. The game represents an image of McCullers's arithmetic formula (3 plus 1): a fourth player is missing. It is the white Southerner who would have the will and the power to stop the South's "cheating" on its theoretical commitment to political and spiritual ideals.

But the story revolves around Frankie, who, at the beginning of the story, is sick of the "silent crazy jungle" she sees as her adolescent world. The term is a reference to the period of The Heart Is a Lonely Hunter that Blount called "crazy" because of people's failure to speak against injustice. That period (of the preceding novel) was, within the perspective of the saga, the world of her childhood, and Frankie is eager for change. Opportunity presents itself in the form of the war, and Frankie's association with the two soldiers constitutes the major development of the political parable in this novel.

While Americans from North and South fought together in World War II, only a child might suppose that this commitment to a national effort would automatically end southern separatism, but then Frankie is a child, and this appears to be what she hoped, for

in her encounters with both soldiers, her frustration with them is caused by their not being what she thought.

Jarvis is wearing the uniform, but he is not committed to the national unity it represents. He is stationed in Alaska, which at that time was not even a state, and where no fighting was going on. This bothers Frankie, and she is even more puzzled when she learns that he is still acting as if he were down South: he is going swimming. Only when he returns to announce his wedding plans does she get really excited because it represents a personal commitment. Furthermore, the girl he plans to marry is herself associated with the North, or seems to be. She is associated with "strange snow" (and snow and cold are always by implication the North in McCullers's work except in <u>Ballad</u> where snow represents both cotton and northern carpetbaggers). Also Janice lives in a town called Winter Hill, but this turns out to be in the South, so it is not what it seems. Even so, Frankie never gives up hope, and all through the story, she looks forward to the wedding, or "union."

Frankie's disillusionment with the idealism of the war is also seen in her encounters with the other soldier. This fellow wears the uniform, and like brother Jarvis, he is from the South. Also, like Jarvis (whose being stationed in Alaska associated him with the North) this soldier is (by implication) associated with fighting for national ideals, for he is from Arkansas. Although Arkansas did secede from the union in 1861, it established a Constitution in 1864 which granted black people the right to vote. So when Frankie is with him, she feels grown up. But something is wrong. She is unable to talk to him; they do not seem to her to speak the same language. And he seems to have no interest in her. He is self-serving, using the war to be away from home and "have a good time." Frankie never understands him, but McCullers makes it clear that he is not committed to the war's idealism in the episode which occurs when he and Frankie first see each other. In this scene, he is trying to buy the monkey from the organ grinder.

Only three things are known about this monkey and he is seen only this once in the story. He is associated with fond memories of childhood, he always goes South in the winter, and he is an "extravagance." Like Cousin Lymon in <u>Ballad</u>, the monkey is a symbol of both national ideal and southern ideal. So literally he stands for the South which Miss Amelia's father is associated with—the period following the establishment of the Republic, when the "paternal edifice" was being built. Also, he also represents the "old South" that Southerners still fondly refer to as Dixie, which stands for southern independence. But he also stands for racial discrimination and segregation—and that is an "extravagance" (or catering to local whim) that the union cannot afford, since it is contrary to what the union stands for. The soldier wants to carry the monkey with him because within the framework of the parable, he is willing to fight for his country, but he wants to retain his southern heritage of separatism. Ironically, however, because of the war, and national commitment to it, the ideal of national unity is beginning to become stronger, so unlike Cousin Lymon, who willingly sat down and consumed southern victuals with gusto (becoming more deformed as he ate) the monkey is not so sure he wants to go with this southern soldier. When threatened by the soldier, the monkey jumps on Frankie's back, and this gives her a queer feeling. While she has a fondness for this monkey, she represents the segment of southern thought that aims for national unity so while his sitting on her shoulder gives her a warm feeling (since it represents her pride in the South of her past) she doesn't want to carry the "monkey" of southern separatism on her back, yet there is something about him she likes.

Frankie's association with both soldiers is accompanied by a linguistic problem, the purpose of which is to indicate that if Democracy and Christianity are to survive, their meaning must be understood. While both soldiers theoretically fight for these ideals, they do so perfunctorily. Jarvis's mind is not on freedom; it is on a girl. The other soldier thinks only of having a good time. Thus while

Frankie talks about the meaning of the war, the strange soldier talks about dancing. When she tries to tell her brother about her plans (her ideals), he calls her "Frankie the lankie the alaga fankie." McCullers emphasizes the idea by having the newspapers misspell her name. The language paradigm underscores the discrepancy between what the two soldiers represent and what Frankie thinks they represent. Their uniforms are deceptive. They are not committed to national ideals (except in terms of winning the war). They are still committed to southern separatism. But there is a difference between them, which is why Frankie retains faith in her brother. This faith is justified in the end, when after the marriage, Jarvis and Janice go to live in Luxembourg, which was noted for its congenial population of mixed national and ethnic origin and for its religious freedom. McCullers's point is that some Southerners did change their perspectives about the South as a result of the war, but not all of them fought for its ideals "back home" after the war.

The importance of precision in language is a major focus in this novel. This is, of course, readily apparent in many ways. The irony of a "War for Democracy" being fought in the background while the main action takes place in a still racially segregated South is one. And language is prominent in defining character, too, in which capacity it sharply defines the relative strength of different segments of the South. Berenice displays a good level of literacy, but is not as capable with the language as Frankie is. She marvels that the child can articulate what she has only felt. At the end of the story she is still using slang, and Frankie is instructing her that it is important to use the proper words for things. John Henry never has much to say, and sometimes he refuses to talk at all. By the middle of the novel, he is repeating what others have said, and by the end, he is reduced to single word utterances.

But the use of language is much more complex than that. There is an emphasis on semantic ambiguity, for instance, with respect to names. Just as the definitive images of dream and wheel appeared in the exact center of <u>Heart</u>, the controlling image in this novel occurs

in its structural center. It is the image conjured up by Frankie's allusion to a play called Camille. This play is about a young girl whose Christian name is Marguerite, but who is known as Camille because of her love for camellias. As Camille, she is a prostitute, but she falls in love and plans to marry. The father of her intended tells her that her reputation will ruin his son, however, so out of love for him, she refuses to marry him. Her lover never finds out her true reasons, so she dies a martyr to love. The pathos of the story lies in her innocence, and this is suggested by a name which does not appear in the play, but which is implicit. The name Marguerite means "daisy" in French. The name changes, which in The Member of the Wedding reflect Frankie's adolescent changes, parallel those in the play. Like Daisy, Frankie is innocent at the beginning When she flirts with immorality (with the soldier) she calls herself F. Jasmine (a flower, like the camellia). At the end of the story, she becomes Frances. These name changes correspond to the shift in her perspective as she comes to grips with her maturing convictions relative to what the war means to her.

These name changes are indicative of shifts in the religious allegory as well. Essentially this level of development traces the ideological transference of the spirit of love for God from one great era to another. Frankie is the Hebrew child of faith. As F. Jasmine, she is a symbol of Christian faith as she (and it) struggle to establish and maintain a strong presence in the world. The "F." in Jasmine's name during this period stands for her Christian name, and is shown in this form of abbreviation because the period which this name designation covers in religious history involves development of identity. The name Jasmine (in F. Jasmine), designating this period, reflects the problems of the church during this period (as immorality was a problem for Camille). By the end of the novel, Frankie has become Frances, which is her full Christian name, and which in this allegory marks the beginning of a new and confident era in the history of religion in the western world.

The time involved in the historical period which McCullers thus evokes would seem to be prohibitive in terms of the literary means to accomplish it, and it was a problem for this writer. Her struggle to accomplish what she wanted with this novel was noted by her second biographer, Virginia Spencer Carr, who says that one night when she was working on it she was said to have cried out, "I've lost the presence of God!" and Carr says that "Many people associated such cries with the novel she [McCullers] continued to wrestle with for over five years before it was finally shaped to her satisfaction."[2] Indeed the logistics of handling the religious allegory was McCullers's problem and the reason for her fitful sleep. In her letters to her husband Reeves when she was working on this novel, McCullers declared that her work was slow because every word had to be just right, like a poem.[3] It did, for allusions to the specific events which could evoke images reflecting divisiveness within the church over such an extended period of time would have to be precise and strategically placed. They are, and recognition of them and their significance requires some effort on the part of the reader, for as one reader has observed, the book is "rather like a chess game, where every move is a symbol and requires the reader's counter-move."[4]

Following <u>Heart</u> in the historical chronology, the religious allegory in this novel begins in the post exilic period. Part I of the book concerns the psychological dilemma of the people with the advent of Christ, and traces their indecisiveness relative to conversion from Judaism to Christianity. The first section opens with Frankie's amazement at what has just "happened." The happening is a puzzle which she cannot quite comprehend. Then we learn that it is the wedding. In the religious allegory, the wedding is a symbol of her brother's decision to commit himself to Christ. Frankie puzzles over this through all of Part I before making a decision as to what she will do about it, and finally decides at the end that her heart has "divided like two wings" and "at last she knew just who she was and understood where she was going. She loved her brother and the bride and she was a member of the wedding." She had, symbolically,

decided to become a Christian. So in the allegory, the wedding represents religious conversion.

The bride's name is instrumental in identifying the symbolic significance of the wedding. Frankie is fascinated by the fact that Janice's name begins with "Ja" like her brother Jarvis' and her own (i.e., Jasmine). She marvels at this likeness between the "Ja three of them." But consistent with McCullers's three plus one formula, there is a fourth which is implicit, for Janice (her Christian name) is pronounced Janus, and this is the name of a god who looked both forward and backward, thus embracing both past and future.

Conversion was a difficult decision, and the novel explores the psychological and intellectual problems which individuals had to face concerning it. Historically, during the post-exilic period, strict adherence to Mosaic law was stressed as a means of strengthening the tribe. Frankie is much concerned with ethics, and chastises John Henry for not obeying the "first beginning laws." She has, herself, however, secretly committed a sin with Barney, and is afraid of trouble with the law as a consequence. The nature of this sin is not disclosed, but on the level of development of the religious allegory, the name "Barney" (which is irrelevant to the action elsewhere) is a reference to the first designation of disciples as Christians, which occurred at Antioch under the leadership of Barnabas. Frankie's sin, then, is that of changing her name (or spiritual commitment) for at this point in the novel, although she is called Frankie otherwise, she slips and calls herself F. Jasmine. So while Frankie was not (in the narrative plot) really in trouble with the law, neither were those who called themselves Christians at Antioch, for there was no real conflict with Mosaic law in this; most early Christians were in fact Jews. But as Christian doctrine began to emerge, there was doubt in the minds of some Jewish Christians as to whether Christ was the real Messiah of the prophets, and they, like Frankie, were uneasy.

A central question of the period involved interpretation of Mosaic law, and Frankie and Berenice get into a discussion about whether the law would be concerned about Frankie's cat or not.

Berenice says it would not, since it is only an alley cat, but Frankie decides to test the law by asking its help in finding the cat despite Berenice's telling her not to trifle with the law. After talking with the authorities, she seems more sure of herself. This is probably an allusion to the Sermon on the Mount in which Jesus declared "Think not that I come to abolish the law and the prophets; I have come not to abolish them but to fulfill them." Frankie worries whether it is "against the law" to change your name.

While Frankie is still undeclared as a Christian, she worries about her appearance, and Berenice tells her she will look better if she will "file down them horns." This an allusion to the painting of Moses done by Michaelangelo in which there are horns on his head due to a mistranslation of the Hebraic word "rays" in the vulgate Bible. When Frankie finally decides to change her name (and be a member of the wedding) at the end of Part I, the event is preceded by the sound of a horn which breaks off. A reference to the significance of this allusion is made in Part III of the novel.

All of Part II deals with the history of the Christian church, and is divided into three sections. The first is the early Testament period, the second, the Middle Ages, and the third, the Renaissance and the Reformation.

F. Jasmine is linked by implication at the beginning of this section with Peter, Paul, and Jesus, as she declares her intention to write letters, feels that she now understands St. Peter, and borrows the carpenter's tools. Inspired, she sets out to tour the town and spread the "gospel" (her plans) to all who will listen. Her steps are directed by remembered music which has touched her heart. It leads her through streets where soldiers walk, and she imagines the far off places they will go as she dreams of evangelism toward eventual worldwide unity. When she arrives at the Blue Moon, there is "no written law to keep her out," and "the old laws she had known before meant nothing to her," for the new F. Jasmine follows the teaching of Paul, who insists that faith comes before law. Law is merely the guide, the custodian of faith. The strength of her faith gives her a

sense of joy because it brings with it a sense of responsibility, a need to be true to herself and to be known for herself. Thus she walks among strangers, friends and scoffers, confident and proud.

By eleven thirty, F. Jasmine is tired of walking through the town and her "need to be recognized for her true self" is satisfied, so she stops in at her father's store. This stop serves to mark a developmental change in the allegory. At the store she learns that Uncle Charles is dead, and when she leaves the store, the church clock is striking twelve, a transitional number in the saga.

Uncle Charles is barely defined (as a character) in the novel, but his name is mentioned several times, and he functions in the allegory as a symbol of major setbacks in the growth of true spirit within the context of the established church. The name first appears in Part I as the name of Frankie's cat, but this animal appears nowhere else in the novel, and the fact of the cat's having the same name as the uncle is not coincidental. One circumstance common to both cat and uncle is that there is something wrong with them: the cat is lost, and Uncle Charles is sick and finally dies. There is considerable ado about the cat considering the fact that he never materializes, has no apparent relevancy to the plot, and is mentioned only once in the story. McCullers is apparently using the cat to establish a symbolic significance to be associated with the uncle.

The cat is something Frankie possesses, but which actually exists in the story only in her mind and Berenice's. Since it is mentioned within the context of Part I, where Frankie (in the allegory) finds her faith undermined by confusion about the Messiah and seeks help from (Mosaic) law, the cat itself seems to symbolize that faith, for it is on her mind, but is lost, so she calls "the law" for help in finding it.

The cat is called by three names, and these are articulated only once in a form which resembles a semantic configuration which similarly appeared only once (and similarly without apparent significance) in The Heart Is a Lonely Hunter. I refer to Jake Blount's saying he likes words: "Dialectical Materialism . . . Jesuitical

prevarication . . . teleological propensity." Blount's three words suggest the nature of that novel's three levels of development. In The Member of the Wedding the word "cat" itself stands for the substance of faith (or organized religious structure). The three word paradigm associated with the cat is "Charles, Charlina, Sweet Jesus!" One is a Christian name, one a nick-name (or diminutive), and one a common epithet. In effect, these three words designate the three major developments of the religious allegory in this novel: the emergence and growth of Christianity, the decline of church power during its long struggle with divisiveness and heresy, and finally, the beginning of Protestantism. The name "Charlina," which here is the nickname for Frankie's cat, refers to the heretical period. During this historic period there was a group called the Cathari, and its nickname was "cat," which implied heresy. McCullers uses the elements of this situation (name, nickname, implication) to form her own configuration.

The name Charles, then, is a symbol of trouble within the church and generally it is divisiveness, or weakening of faith. When Uncle Charles is introduced in the first chapter of Part II, the religious allegory has reached a point where historically the enthusiasm of the early testament period is turning into the despondency of the early medieval period known as the Dark Ages. McCullers associates the beginning of this period with the death of Charlemagne, for historically, he brought Christianity to great heights, but following his death, it declined. Thus in the semantic paradigm, the word "Charlina" follows "Charles" and is a diminutive.

Following the announcement of Uncle Charles's death (while she is at her father's store), F. Jasmine's journey takes a turn for the worse. She feels that something is wrong. Angry voices bring her to the scene of a confrontation between the soldier and the monkey and the monkey-man. Surely an allusion to the threat posed by barbarism during these desolate times (in the religious allegory) the monkey-man symbolizes monasticism desperately trying to recapture a sustaining spirit (the monkey). The monkey is, like the

cat, an animal, and ironically, both are symbols of spirit. The monkey jumps on F. Jasmine's shoulders, which is an image of the idea that the burden of maintaining spiritual vitality rests with the individual, not the church.

The rest of the section delineates the confusion and spiritual abyss of the latter part of the dark ages, as F. Jasmine wanders into territory dominated by the soldier and his "double-talk" with which she cannot cope. The section ends with a schism foreshadowed by mention of Uncle Charles's death. F. Jasmine passes an alley and sees a "dark double shape," which reminds her of the wedding, but which in reality is only two boys leaning on each other. This image appears to signify the division between the Eastern and Western branches of the Roman Catholic Church.

The first part of section two of Part II deals with the Middle Ages, and McCullers alludes to it as "the cake that failed" (cake representing the church). She is being both ironic and paradoxical, for the Catholic Church probably reached its greatest extent of power during the Middle Ages, over both the spiritual and the secular world. But from McCullers's humanistic viewpoint, its greatest success in wielding power was also its worst failure in terms of its aiding the growth of individual freedom. She is careful to specify that it is the "old Frankie" that loved the soggy innards of a failed cake, not the F. Jasmine who is the Christian spirit within the medieval religious context.

The age was characterized by the church's struggle for independence and sovereignty, and throughout the chapter, F. Jasmine asserts her authority. She insists that her belief about the wedding is correct, demands that Berenice put pleats in her dress, instructs John Henry to ignore Berenice, and even tries to tell Berenice what to do with her life. Her independent spirit is emphasized by her plan to secretly meet the soldier on a date.

Historically, one of the major developments of church power during this time was its widespread influence over the common people, and a contributing factor in this was the new doctrine of the

Lord's Supper. The sacrament of the communion gave the clergy great power over the people because it had to be performed by an authorized ecclesiast, and failure to observe it meant excommunication. With the people thus essentially drawn more closely into the church, their religious impulses were revitalized. The church itself was stronger, and the spirit of love was in turn stronger in the lives of the common man. McCullers alludes to this situation with the episode in which Berenice, F. Jasmine, and John Henry sit down together to eat what they call their "last supper."

During this meal, Berenice tells a story about a boy named Lily Mae Jenkins, who through love, changed "his nature and his sex." The boy himself does not appear in the novel, so the story is another image, perhaps an allusion to transubstantiation. Sexlessness in McCullers's work is indicative of "oneness," and is therefore a symbol of unity and of God. A number of readers have noted and discussed androgyny and its implication of universal love in her works.[5]

Another historical development which helped to revitalize the church during the Middle Ages was monastic reform aimed at putting an end to dissolute practices which had become commonplace and demoralizing. One reform was the institution of stringent rules aimed at conveying a new image. McCullers evokes the idea of new consciousness of appearance in a change in F. Jasmine, who previously had cared little about how she looked. At this point in the story, she studies her face in the mirror and struts about in her newly purchased wedding clothes, seeking Berenice's and John Henry's approval. The new rules, like F. Jasmine's dress, had little effect, as McCullers indicates with the brief dialogue with respect to F. Jasmine's new image. Berenice says the dress is the wrong color, that it makes her head look peculiar, and that there is a brown crust on her elbows. "You have to cut your suit according to the cloth," she says. John Henry says she looks like a Christmas tree, or (with reference to the allegory) a spiritually impure (worldly) image. This might be an allusion to the admonition of Pope Gregory VII, who

asserted that if the church wanted to improve its image and be independent, it had first to become pure.

Another significant development within the church which helped to strengthen it was the Crusades. As F. Jasmine rests at the table between periods of eating, she crosses her knife and fork on her plate, the sign of the crusader, and begins talking about "hopping-John." She wonders what this southern dish of peas and rice is called in French. Historically, the first crusade was prompted by a fiery sermon delivered in French, in 1095, by Pope Urban II.

But the Crusades were less than a rousing success, the sacrament became the center of a power struggle between church and state, and the image so rigorously sought became tainted by heresy from within. McCullers introduces the section with another mention of Uncle Charles being dead, and this time the event affects the three characters in the defaced kitchen, for it means (in the plot) that Berenice and John Henry will now also go to the wedding, which causes dissension between F. Jasmine, Berenice and John Henry. Doctrinal struggles within the church are suggested by allusions in the characters' conversations. F. Jasmine insists on having her (clerical) collar like she wants it and Berenice tries to snatch it away. They argue about the Covenant (discussion of Noah and the Ark), the trinity (whether two is company and three is a crowd), and the authority of Apostolic succession (her father's pistol). Berenice tells F. Jasmine she needs to change, and F. Jasmine thinks Berenice is not in her right mind. Near the end of the conversations (which represent the end of the period) Berenice institutes a sort of inquisition about F. Jasmine's activities downtown, and F. Jasmine suddenly changes the subject and dons her new dress for inspection. Bernice has no trouble at all seeing that the new image is ludicrous, for the dress symbolizes church image during the period of the Inquisition.

About this time Uncle Charles is mentioned again, which (within the allegory) announces another major split in the church. The talk in the kitchen of seven dead people identifies this as the Great

Schism, as it was called when Pope Clement transferred the papacy to Avignon where it remained for seventy years under the rule of anti-popes before being returned to Rome, an event which climaxed the period of shifting papal authority.

Another element which served to undercut the power of the church toward the end of the period was Mysticism. This was the idea that religion should consist of vital and direct spiritual contact between the individual and God, which obviously left the church out of it. This idea is reflected in Berenice's discussion of why she will not marry T.T. He shows all the outward signs of being a good man, but there is no vital contact between them: he does not make her "shiver."

The second part of section two of Part II is the real center of the novel, and it deals with humanism. As the section divides the text, the Renaissance marks the shift in emphasis from a religious to a worldly perspective. Thus the scene opens with the "Holy Lord God," Berenice, John Henry, and F. Jasmine's voices raised in criticism of God and judgement of the world. The time in the novel is "at the end of the long stale afternoons," and the beginning of "a different day."

The new day is characterized by a change in how the dream of divine love is seen or told. The image McCullers creates has three parts. F. Jasmine graphically describes the scene in the alley where she had seen a shadowy double form, and Berenice says this is the first time she has heard a feeling put into words. They talk of love, and the play Camille is mentioned. Then Berenice tells a story. McCullers has conveyed the idea of new perspectives relative to art, drama, and literature.

This new direction is vulnerable to the possibility of divisiveness, however, as McCullers signals with mention of Uncle Charles again. The danger lies in the nature of man, for if given the power of judgment based on individual knowledge and conscience, he might lack the wisdom to discern the truth. McCullers employs symbols and semantics to convey the idea. F. Jasmine, as the true spirit of

the ongoing quest for "the dream" has a vision of the free world which includes a better "law of gravity." In other words, it stresses individual, as opposed to clerical interpretation of scripture. Berenice, exemplifying the average man, plays the devil's advocate to F. Jasmine's humanistic idealism. She draws on her own experience to illustrate the dangers of humanism, and what she says is embodied in a sort of mini-parable. She tells that her first husband, who was perfect, was named Ludie Maxwell Freeman. The name is a combination of three concepts, the last obviously implying freedom. The name "Ludie" refers to Emil Ludvic, who wrote a book called <u>Jesus, Son of Man</u>. The middle name, "Maxwell," in lower case is defined as a measure of force (which corresponds to F. Jasmine's reference to the force of gravity within the same context). Together, the message of the name is that goodness in man is measured by the amount of freedom that he has.

Berenice tells of her search for another man like her first real love, but says that while all the men she found reminded her of him, they all fell short of what attracted her to him. The story suggests that man is flawed, and thus unable to interpret God's word.

Earlier in the section, Berenice had tried to snatch F. Jasmine's collar away so she could make it look more perfect; at this point we learn that she has slyly turned her attention to it again and gotten it pressed with an iron. When F. Jasmine sees this, she is frustrated, not knowing whether to embrace or despise Berenice. Relative to the allegory, the collar is an allusion to the clerical collar.

The final part of this second section in Part II evokes the most essential aspect of the Reformation from McCullers's viewpoint. At first there is much talk of name-changing, which leads into a philosophical discussion about the significance of names in terms of real identity. F. Jasmine becomes strangely excited and picks up the butcher knife, which is symbolic of the Christian sword. Then the characters discuss how everyone, whether he knows it or not, is "caught and loose" some way, which reflects Luther's idea expressed in <u>The Freedom of the Christian Man</u> that man is free from church

rules, but bound by the responsibility of witnessing to his faith. After this, the characters briefly weep together for the passing of all things, and then F. Jasmine, the individual whose identity now fits Luther's definition of a Protestant prepares to face the world with a clean face in the light that is "sudden and sharp after the darkness."

The third section of Part II delineates the beginnings of Protestantism. F. Jasmine is out on the street again, but this time she is free (in the allegory) of church authority; she has given John Henry all her old costumes, signifying her new identity. The future is not entirely rosy, however, as when she has her fortune told, the wording of it and the action immediately following suggest that ideological divisiveness which has plagued Protestantism during the Reformation will continue, and especially when it is removed to America. An allusion (Ludie) to the historical debate between Luther and Erasmus concerning the nature of man is made, and is relevant because of its question as to the reliability of man's reason in a future nation where man is politically free to worship as he chooses.

The incident in which F. Jasmine hits the Arkansas soldier over the head with a vase appears to allude to rejection of Calvinism, and the bus trip home from Winter Hill (which is so desolate, and seems to represent repression for the Protestant) suggests the resurgence of Catholicism during the counter-reformation period. Later, as F. Jasmine attempts to escape (the town and parental authority) she is halted as her father calls on the law to stop her. This appears to be a reference to Queen Elizabeth's decree which forestalled separatist revolt.

In the coda, or final section of the novel, Frances says she is "mad about Michaelangelo," a double entendre signifying both her strong religious fervor and her anger that (symbolically as the individual committed to God) her commitments relative to how she worships Him have resulted in uncertainty and confusion. Functioning essentially as an epiphany, the statement emphasizes the identity problem which has dominated the novel on all three levels of its development.

Unity, as symbolized by the wedding, turned out to be a premature hope on the part of an aspiring mind, but Frankie, as the religious spirit of the allegory, the democratic spirit in the parable, and the intellectual mind of the South on the realistic level has come to understand the importance of asserting her own individuality and assuming personal responsibility.

Individualism is emphasized in this novel in a number of ways. For instance, there is an emphasis on eyes (another word for which is "I's, i.e., individuals). Berenice has two eyes, one real and the other glass, and others' eyes are described as well. Frankie talks of the "we of me" which in first person is the "I of us." The dream of political and spiritual unity is portrayed by the metaphor of the wedding, but the emphasis in the novel is not on the wedding but on the "member," the one who is not in the wedding, the individual.

In Part III, Frances has established her identity as an individual. Strongly asserting herself to Berenice on religious matters, she is sure of herself as a Protestant, and has matured sufficiently to have enough confidence to face the future side by side with Catholicism in the figure of her friend Mary Littlejohn.

Relative to the political parable, she will not leave town (the South) as, ironically, McCullers herself did, but will continue to be dominated by her southern heritage (her father) and (southern) Law. However, she is now mature enough to deal with these problems, at least to some extent.

The set of pictures Frankie paints link this novel with others in the saga. In The Heart Is a Lonely Hunter Mick drew four pictures. Three were images of conditions in the South. The fourth was a picture of a seagull being dashed by the wind over the ocean, apparently an image of freedom (Mick had never seen the ocean). In The Member of the Wedding Frankie paints four pictures, too. Three of them are images related to the narrative, parabolic and allegorical levels of development. One is a Christmas tree, which represents a spiritually impure (or worldly) image relevant to Christianity. Another is a freak soldier, which alludes in the parable

to the participation of the Southerner, with his limited idea of freedom, in the global fight for freedom. The third one is of flowers, which alludes to the developing young spirit of an individual (and echoes the <u>Camille</u> allusion). The fourth picture is of an airplane, which alludes to nothing in the story. It represents an idea which has not yet become a reality. Therefore it would appear to have no relevance to this novel, but it is related to a novel which McCullers had not written at this point: <u>Clock Without Hands</u>, for in this novel another "J" character named Jester actually owns a plane and flies it, solo, another "name" for which is, as an individual.

<u>The Member of the Wedding</u> seems to end on a generally pessimistic note, for John Henry dies, Honey Brown is in jail, Berenice is resigned to marrying T.T., and Frankie is disappointed, disillusioned, and stuck in the town. But all of this is deceptive, just as the historical implications of the present are seldom recognized until the future. Berenice is compromising her ideals, of course, but she is making an alliance which will benefit her, giving her a new status. Just as Brannon's giving a job to a young black man in the earlier novel had suggested Blacks' need for jobs, Berenice's marrying T.T. in this novel focuses on the idea, and shows progress. In the thirties, black women had to work in white people's kitchens because black men could not compete with white men for the available jobs. After the war, black women are still in white kitchens, but their men have jobs too. John Henry is dead, but his childishness is a handicap for the South. His counterpart later in <u>Clock Without Hands</u> will be weaker than John Henry was, for he will lack the close relationship that John Henry had with other Southerners. Sammy Lank (in the later novel) represents a fifties version of John Henry. Sammy is older, but is not a member of the "family." In <u>The Member of the Wedding,</u> Honey Brown is a young black man whom other Blacks considered crazy because he advocated black rights. Frankie had run into him and advised him to use reason instead of violence in his quest. Instead, he began to use marijuana and broke into a drug store (an image of the site of government which is emphasized

in <u>Clock Without Hands</u>). So his being jailed is bad for him, but clearly points to the idea (implicit in all the works) that unity must be attained under law, not through violence. Frances may be caught by time and circumstance, but she is making plans for the future, and her spirit will next be seen in the saga as a young woman who will be a member of a wedding—her own—indicating progress in the slow flowering of the dream.

THE SQUARE ROOT OF WONDERFUL

When we are lost what image tells?
Nothing resembles nothing. Yet nothing
Is not blank. It is configured Hell:
Of noticed clocks on winter afternoons, malignant stars,
Demanding furniture. All unrelated
And with air between.

The terror. Is it of Space, of Time?
Or the joined trickery of both conceptions?
To the lost, transfixed among the self-inflicted ruins,
All that is non-air (if this indeed is not deception)
Is agony immobilized. Whilst Time,
The endless idiot, runs screaming round the world.

— Carson McCullers, "When We Are Lost"

"The World of Tomorrow: A Trylon and a Perisphere"

(New York World's Fair, 1939)

The Square Root of Wonderful is the fourth work in the historical chronology of McCullers's saga, and it differs from the others in that it is a play rather than a novel. Furthermore, it was a distinct failure on Broadway when it opened in October, 1957, and has attracted little attention, either general or critical, since it closed after only forty-five performances.

Its main character is a young woman named Mollie Lovejoy, who has twice married and been divorced from the same man, Phillip Lovejoy. Phillip is a writer whose first book had been very successful, but whose later attempts to write a play had failed, sending him into such depression that he had entered a sanitarium, which is where he is when this play opens. Meanwhile, Mollie has met a young architect named John Tucker, to whom she has rented a room in the barn. He is in love with Mollie and wants to marry her and build a new house for her and her son. The son's name is Paris, and the three of them currently live on an apple farm owned by Phillip's mother who, with her daughter Loreena, has just arrived (when the play opens) for a visit with her daughter-in-law and grandson.

When the first scene opens, Paris is having a nightmare. He is sleeping on the sofa in the living room (which constitutes the setting) because his room has been given to his grandmother and his aunt. It is the middle of the night, but Mollie is awake (for she and John have been talking late in the kitchen) so she enters and calms him down, after which he decides he will spend the rest of the night in the library. As he leaves, Sister Lovejoy (Loreena) comes in, saying she has been wakened by the wind, and she is followed shortly by her mother. They inform Mollie that Phillip is on his way to the farm to see her, and after a little conversation, both they and John go off to bed.

At this point, Phillip arrives. He tells Mollie he wants to win her back, and it is clear that she is still attracted to him, so after a bit, she succumbs to his charm and they go off to bed together. Thus begins the conflict around which the play turns: Mollie must make a choice between Phillip and John.

The two men are quite different. Phillip is an artist—impulsive, emotional, and articulate. He is bright, witty, and persuasive. But he tends to extravagance in all things, and is virtually incapable of dealing with reality. For instance, he desires marriage, but has (we soon learn) committed polygamy. He abhors milk, but has three-hundred gallons of homemade applejack hidden somewhere on the farm. He sees

himself as a sort of Thoreau figure, and the farm as his Walden Pond, but has no interest in it. He pounds his typewriter, but has lost his writing talent and is unwilling to try anything else.

John, on the other hand, will do any job that needs to be done. He temporarily forsakes his professional career to stay on the farm and do odd jobs, since it means being near Mollie. While he lacks Phillip's gift with language, he has a talent for listening, and respects what others say. He is also interested in exploring the meanings of words. He is an architect who knows the importance of solid foundations in relationships as well in houses, and is willing to work for them.

John openly declares his love and waits for Mollie to consider. Phillip, on the other hand, seduces her and then rudely informs her that he does not even love her, arrogantly insisting that she marry him again anyway because he is weak and needs her.

In the end, she chooses John, and when Phillip learns of her decision, he commits suicide. The play ends as Mollie, Paris, and John plan a new house and a future together.

Thus summarized, the play would appear to have a good deal of strength, with its action centered on the love triangle, and its characterization suggesting the plight of the artist in his attempt to reconcile his creative impulses with his need for domestic stability. But as these themes develop, others appear as well, are pursued briefly, and dropped. Reviewers were nearly unanimous in their opinion that McCullers had not integrated the several themes, and that the play failed to maintain focus or tone. Oliver Evans, McCullers's first biographer, in assessing both their comments and the work itself, summarized the situation when he asserted that the work was simply too full of "a variety of minor motifs . . . to maintain its unity"[1]

The "minor motifs" are, of course, relative to the play's development of the saga, and it may be that McCullers's relative inexperience in creating drama led to problems for her in terms of expressing it through this medium. But her ability as a playwright is

academic here. The fact is that the play does demonstrate her artistic integrity within the parameters of the saga and therefore may, in the long run, contribute to her having a more secure place in literary history than she might have had with a single smash hit on Broadway.

While the realistic level of development in this play deals with a love triangle, its ideological center is a historical event which (as in each of the other works in the saga) provides the central focus. That event is the Supreme Court decision to override state legislation involving racially biased restrictive covenants in housing. McCullers's choice of this event as the focal point of the play is consistent with her choice of World War II as the central event of the novel in the saga which precedes this. The war was a symbol of people fighting together for democracy, black and white, North and South. The Supreme Court decision is a symbol of moving toward a consummation of the idea in peacetime, through law. In The Member of the Wedding the main character was an adolescent who wanted to be a member of her brother's wedding, which, on the level of the political parable's development meant that one segment of southern society was eager to end southern isolationism and bigotry and figuratively re-join the Union. This individual was prevented from taking action not only by her own premature and precipitous actions but also by her family and the law, the latter being the instrument of her ultimate humiliation and defeat, as it was a policeman who captured Frances at the Blue Moon Café when she tried to run away. In The Square Root of Wonderful it is demonstrated that before a (symbolic) wedding can take place between the separatist South and the North there must be a "divorce" from previous southern ideological commitments, and a solid legal basis on which to forge a new union. The fact that Mollie has twice divorced Phillip previous to the opening of the play suggests that the segment of southern inclination which she represents has tried to make a definitive change in the South but is so emotionally committed to the region that these efforts have failed. McCullers's emphasis is on the need for

individuals to transfer their emotional and spiritual commitments to a broader political and religious perspective.

The play suggests that a significant number of individuals in the South are moving in this direction. The kitchen in <u>The Member of the Wedding</u> represented regional (emotional) confinement. In the play, the kitchen at the farm serves as a symbol of the same thing, but Mollie moves freely (and often) in and out of the kitchen. She has the emotional support of John and (implicitly) legal support of the ideals to which she subscribes, besides which, she is demonstrated to have a mind of her own, and some determination to have an effect on the future.

In the drama, this is conveyed by her having named her son Paris. A good deal of discussion (in the play) is about why he was given this name, which focuses on its importance. Mollie says the name reminds her of "far off" places. The "far off" place is Paris, France, and McCullers apparently intends this "far off" place to suggest political principles she embraces: the French flag is blue, white, and red, and the French motto is "Liberté, Egalité, Fraternité." But the name "Paris" is also a combination of the word "par" which means equality, and the present tense of the verb "to be." The implication of Paris's name, then, is that it is a symbol of hope for liberty, equality, and brotherhood in America. The name (Paris) also suggests that parity exists, (as in fact, it does in theory, under the housing law).

All of the characters have symbolic roles, of course, in the political parable. Mollie is the literary descendent of Miss Amelia, Brannon and Frankie in representing a segment of the South in (implicit) conflict with its segregationist and isolationist traditions.

John Tucker represents a segment of the North which is determined to unify the nation. Allusions in the dialogue identify his symbolic status. He lives in New York, and he met Mollie when he was walking down a road and she stopped and picked him up, bringing him to the farm. When he asked why she did that, she replied that it must have been "instinct," but that she needed some help on

the farm. He then said that if they hadn't met on the road, they "would have met somewhere else," and he specifies "the Statue of Liberty . . . or in the Panama Canal." This sort of curious remark is apparently an example of how what Evans called "motifs" are introduced in the play and which appear to have no reference to its theme. Within the context of the parable, however, John's comment explains that the meeting between Mollie and John involves a meeting of minds between two Americans whose love for country might become so strong that it could prevent the necessity of a long, arduous struggle to get around an obstacle (southern intransigence) to national unity.

Paris informs us that immature Southerners still cause problems when he describes how his schoolmates ridicule his name and sometimes beat him up. But the Lovejoy family represents the dominant reactionary force in the white South, and Phillip (Paris's father) is spokesman for that group. He stands for both white supremacy and separatism. The literary descendent of Marvin Macy, Mick Kelly and John Henry, he is better educated than they and more articulate, but like Macy, he has a streak of cruelty in him, for he has no respect for other people. While Mick's bigotry was expressed without thought, his thoughts are clear, and he presses them on others. Like John Henry, he is a cheat, but his activities are not limited to card games: he cheats on his wife.

Despite his "indiscretions" Mollie loves Phillip (in the same way that Frankie loved John Henry) because he is "family." They met at a Peach Festival, and he seduced her in a briar patch, suggesting the alliance of the best and worst of southern image. Their subsequent relationship and marital problems (which are described, but not part of the dramatic action of the play) are essentially a record of the general conflicts among Southerners as, in the early twentieth century, they fought among themselves over racism and isolationism.

Mollie and Phillip's first divorce was precipitated by his mistreatment of her, which she claims consisted of first, accusing her of using clichés, then beating her and forcing her out of the house

naked, and finally committing polygamy. The first suggests rhetorical confrontation over principles. The second indicates that his views prevailed in political, social, and legal matters, whereby he exposed her ideas to ridicule. The third suggests that he got tired of their (ideological) incompatibility and sought liaisons with other segments of southern society.

She married him a second time because she was physically and emotionally drawn to him, and she did not want to live with him "in sin." This means, simply, that union must be under law (a point which McCullers stresses throughout the saga).

Their second divorce was precipitated by Phillip's finding a love in Mexico (which in McCullers's "language" means way down South). This seems to allude to the historical fact that diehard southern extremists founded and became committed to a states' rights Democratic party called the Dixiecrats during the period, and this new political party was so far right that it even objected to the Democratic party's civil rights program. The Dixiecrats were strong enough to run a candidate for President, but their extremism ultimately led to political suicide, which explains Phillip's action at the end of the play.

Like his marital difficulties, Philip's writing career symbolically provides background information about the recent history of the isolationist/segregationist's struggle for power over moderates in the South, and concomitantly traces the gradual breakdown of this power as the moral and intellectual dishonesty at its roots proved too weak to withstand scrutiny and acceptance, especially in the face of encroaching national authority and power. Phillip completed two books and one play. The first book is said to have been a huge success, and it is also said to have been called The Chinaberry Tree. This title is an allusion to a tree that is common in the South. It has white flowers and orange-brown berries. Implicit in Phillip's being said to have had success with this book is that in it he promoted white supremacy (flowers being more beautiful than berries) and a white racist public approved. But this is ironic.

The title is also an allusion to a novel by the same name which was written by a southern black writer named Jesse Redmund Fauset, and published in 1931.[2] The subject of Fauset's novel is miscegenation and its consequences in terms of personal insecurity, social ostracism, and moral condemnation suffered by the children resulting from it. Since Phillip is a racist, it may be presumed that this was the topic of his book, and that its message would be a warning to Whites to stay away from Blacks or suffer the consequences. Historically at the time, this was one of the strongest arguments that racists used against integration of any sort, and it was usually followed by the question (posed to Whites): "You wouldn't want your sister to marry one {black}, would you?" The emotionalism thus aroused was very successful for awhile in the South, which accounts for Phillip's first book's having been a success.

But the allusion to Fauset's book is full of irony, for while the subject of the book is exactly what Phillip appears to have believed it to be (unpleasant consequences of racial integration), this is not its theme at all, and the fact that Phillip should have named his book after it suggests that he does not read carefully and sees only what he wants to see.

Jesse Fauset's novel, <u>The Chinaberry Tree</u> says the opposite of what Phillip thinks it does. It is about a southern white aristocrat and a black servant girl who fall in love and have a child. Their love is so strong that despite the fact that they cannot marry (for open and legal marriage between Whites and Blacks was forbidden) he supports her all of her life, and she is true to him despite his eventually marrying a white woman. They suffer, but not because of their love. They suffer because constrictive southern taboos prevent their expressing their love in any socially or legally sanctioned way. Similarly, in a sub-plot which deals with the possibility of incest (as a result of miscegenation) the point of Fauset's novel is not that miscegenation is wrong, but that failure to disclose it is, since that failure could lead to the tragedy of incest.

Fauset's theme is therefore not racist, but similar to McCullers's own. She demonstrates the power of love and union between persons regardless of race, and advocates respect for others despite their differences. She shows that people are pretty much alike no matter what the color of their skin, and that real love does not recognize superficial barriers. And she demonstrates how important it is to feel confident about who you are, and take pride in responsibility and commitment.

In alluding to Fauset's novel, McCullers defines Phillip as a pseudo-intellectual who does not comprehend what he reads, but picks up snatches of it and shapes it to suit his own inclinations and to support his purposes. The success of Phillip's first book thus represents a satire on the success of the southern white supremacists whose arguments against racial equality were specious, and on the gullible segment of the southern population, black and white, who believed them.

To demonstrate that these arguments gradually became less effective in swaying public opinion in the South, McCullers lets us know that Phillip's second book was not so·successful as his first. In fact, its title is not even mentioned.

His third artistic effort is not named either, but details relevant to it indicate that his particular brand of propaganda is no longer viable in the South of 1948. It is a drama instead of a novel, and it is said to have been rejected in Boston (a symbol of American freedom). McCullers suggests that Phillip's audience is becoming more national in its thinking, and less receptive to his ideas when they involve extremism (dramatic action). Public rejection of Phillip's play led him to withdraw from public view: he retired to a sanitarium, which is where he presumably was when the curtain opened on the first act of McCullers's play, The Square Root of Wonderful.

But that opening itself is focused on the threat which Phillip represents, for when the curtain rises, Paris is having a nightmare, specifically about his fear that his father may burglarize the house.

In other words, the attitudes which Phillip represents still pose a threat to the "house" (the South), and are associated with violence.

This fear is seen not only in Paris's nightmare but also in another character in the play, Hattie Brown, who represents the black population of the South, and who is afraid of Phillip. She does not appear black, and is played (in the drama) by a white person. However, as was suggested earlier, her first name (Hattie) was at the time a popular name in the black community, and her last name is Brown, which implies her relationship to Berenice Sadie Brown and to Honey Brown in <u>The Member of the Wedding</u>. In the play, Hattie is afraid of Phillip, and in fact this appears to be one of the main reasons she is in the play, other than to demonstrate that conversely, she is comfortable with Paris. Her symbolic role is shown in her conversation with him when she declares that she had trouble remembering about Thomas Jefferson and the Monroe Doctrine (when taking a test at school) because a fly was bothering her. This suggests the idea that current southern treatment of Blacks renders concentration on historical precedents for protection of people's rights in America difficult. Phillip's presence (when he does actually arrive) in the house evokes fear.

The reason that Hattie's role is played by a white actress is twofold. First, it is because Paris (her friend) represents equality under the law, and thus he sees her without making any distinction as to the color of her skin. Second, it is because the focus of the saga on the realistic level is on the evolution of human rights during the formative years of the Civil Rights movement in the United States. In <u>The Member of the Wedding</u>, the color line was seen to be disappearing in small ways. Berenice Sadie Brown had one blue glass eye. In the novel which follows <u>The Square Root of Wonderful</u> in the saga, the major black character (Sherman Pew) has two real blue eyes. In both <u>Member</u> and <u>Clock Without Hands</u> the color of the eyes is aimed at conveying how these characters see the world, that is, from an increasingly Caucasian perspective (i.e., the assumption that they, black people, have equal rights). But in the play, the

emphasis is on how white people (associated with the law) perceive black people. Since Paris is a symbol of the legal position, his view of Hattie as an equal indicates a shift in how white society is beginning to view black people.

In McCullers's "costume plot" for the play, she was very specific as to what her characters should wear, even down to the color of their shoes and scarves, yet she did not list Hattie Brown's apparel at all. The reason is that it is unimportant what Hattie wears; what matters is that she be seen as a person. In her first scene with Paris, she mentions their having taken their clothes off and having "looked at each other," which means that Paris sees her as a human being, not as a different color.

In the only other scene in which she appears, Paris says he will give her two gifts and a kiss. One gift is an old costume; the other is a sled. The first means that he (symbolically as the new legal perspective) will give her the right to appear as she always has to the white South, that is, black, but that she need no longer be afraid of being what she is, for being black will no longer make a difference under law. A sled is a means of moving in the snow, and snow, in McCullers's work symbolizes the North. Symbolically, he will leave her with a vehicle by means of which she may enjoy a lifestyle that, theoretically, has, in the past, been possible only in the North. That vehicle is the law.

He hesitates to kiss her, he says, because she is a girl, and while this might be construed to mean that he makes distinctions between people, I think rather that it is to draw attention the fact that he does not. Simply, he has been taught that "you're not supposed to smooch with girls on account of their self-respect," so the point is that respect for others is important, law or no law. The title of the play supports this assumption. Although the meaning of the title is not actually or specifically defined in the dialogue, the square root of sin is clearly defined, and its definition is humiliation, so the square root of "wonderful" is therefore respect.

Mother Lovejoy (Phillip's mother) represents how many Southerners during the decade of the thirties had romanticized the "Old South" and her resemblance to Amanda Wingfield in Tennessee Williams's <u>The Glass Menagerie</u> has been noted.[3] Like Amanda, she prattles about the days of chivalry and charm, cotillions and daffodils, and in the process, glosses over the rough spots, like the husband who deserted her. And like Amanda, she has two children, a son who is an artist, and a daughter who is a spinster, and she has tried to dominate them both. But unlike Amanda, she has a great deal of power, and a store of common sense.

Her power comes from an inheritance, and while the details regarding it constitute less than half a page of dialogue in the drama, they indicate an important element in the thinking of that segment of the mind of the South which she represents.

The relative who left her a sum of money is said to have been so distant from her family's everyday life that they hardly remembered him, and certainly never suspected that he might be associated with "stocks, oil wells, [and] business ventures." Neither had his appearance at her doorstep aroused much attention. He had simply showed up, announced his intention to stay, and asked "Aside from the greens, what else is there for supper?"

The food people eat is always an indication of where they come from with respect to their symbolic roles in McCullers's work. Unlike Cousin Lymon, who gobbled up all the southern "vittles" Miss Amelia had to offer, Mother Lovejoy's kinsman indicates that he is not interested in southern food, yet during the next eleven years which he spent with her family, he ate (she says) "buttermilk ice cream every day." Buttermilk is a southern staple, usually combined with either corn meal or flour to make cornbread or biscuits. Ice cream is cold, which in McCullers's vocabulary indicates North.

The name of the relative to whom a taste for this unappetizing combination appeals is Uncle Willie, of whom it is said that his only other interest in the place was to keep its sewing machine oiled and its yard raked, details which suggest that his contribution to the family

consisted of keeping its machinery intact and its public appearance respectable. Like Cousin Lymon in <u>The Ballad of the Sad Café</u>, he is related to the southern "family" and his first name (Willie) resembles Lymon's last name (Willis) except that it is a diminutive, and he is an uncle instead of a cousin. Sam is also the diminutive of Samuel, so Uncle Willie is a symbol of Uncle Sam, and in the play represents the fact that the principles of democracy, which, although treated as "poor relations" by Southerners during the nineteenth century, were still "family." After all, Southerners were still Americans.

So although clearly resembling the character Amanda in Tennesee Williams's play, Mother Lovejoy offers a great deal more insight into the legacy of the South. Clearly the historical descendant of her literary forbears within the dimensions of McCullers's saga, she is strong in the way that Miss Amelia was strong, as standing for the better impulses of the South. Both of these women "took in" their kin, no questions asked—an old southern tradition often articulated: "home is where, if you've got to go, they got to take you in." Like Brannon, she is not only a businesswoman (she bought the apple farm, apparently as an investment, since she doesn't live there) but is interested in promoting education. One of her children is a writer, and the other is a librarian. And like Mr. Addams, Frankie's father, who was aware of how John Henry was defacing the kitchen walls (a symbol of how the lower classes were creating an ugly image of the South) Mother Lovejoy seems to accept what she cannot change.

Mother Lovejoy says that Uncle Willie left her a "fair will," and this phrase is repeated several times to emphasize it. The phrase means "the will to be fair," which is the Constitutional imperative. The phrase thus defines the attitude of the southern aristocracy as one which does not actively promote integration between the races, but is willing to support the law (in the case of this play, fair housing law). Although representing southern tradition, Mother Lovejoy represents that segment of the South which remembers American tradition as well.

While Paris is the main beneficiary of Uncle Willie's will, (which is America's political legacy) Mother Lovejoy's daughter, Loreena, is also an heir. Called "Sister" in the play, she is described by Evans (McCullers's first biographer) as "*a homely spinster who compensates for the drabness of her situation by inventing fantasies involving Latin lovers.*"[4] The fact is, however, that this is merely an image that McCullers creates to convey the way men might view her, and thus constitutes a satire on the (at the time) male perspective of women in the South. Actually she is described as having grace, charm, daintiness, radiance, and breeding. Merely, she has no use for the kind of traditional southern coyness and flirtation which men of the Old South found attractive and thought indispensable in a "lady." Such insincerity of behavior apparently made Loreena sick, for it should be noted that while she is Mother Lovejoy's daughter, she is not called "Miss Loreena" (which would indicate Old South); she is simply Loreena, and represents a new South. Her having vomited on the dance floor when forced to flutter and dissemble at the cotillion suggests her repugnance for the way women were expected to behave by southern tradition.

Mollie describes Loreena as an intellectual, and details associated with her confirm this assessment. She wears glasses, defines the meanings of words about which Mollie is confused, and works in the library. She does seem to live in a fantasy world, but this seems to indicate merely that she uses her creative mind to escape the fantasy world of the "Old South."

The fact is that Sister is associated not only with intellectualism in the South but also with an idea that is central to the theme of the saga: evolution. This point is made in a section of the play's dialogue which seems truly bizarre. Mollie describes "Sister" to John as someone who whispers (because she works in a library) and who "once fell in love with a man in Z," (meaning the "Z" section of the library's cataloging system). The man is said to have been "just taking out <u>Rats, Lice and History</u>, by somebody called Zinsser."

This sounds strange and irrelevant to the action of the play, but in fact it is an allusion to a real book. This book purports to be a serious biography, describing the life history of typhus fever, but in essence, it is a satire on man in which his behavior is demonstrated to be similar to that of all living things, including infectious diseases, which are defined as "one of the great tragedies of living things—the struggle for existence between different forms of life."[5]

Much of this book is devoted to a discussion of the history of western civilization in terms of its wars, with the author citing statistics to demonstrate that infectious diseases have done more to determine the outcome of battles than the victorious generals would have you believe. The direction of the satire becomes more specific relative to McCullers's purposes, finally, with Chapter 12 (which is a number associated with her saga's design) when, as the sub-title of this chapter says, "We are at last arriving at the point at which we can approach the subject of this biography directly. We consider intimate family relations, immediate ancestors, and gestation of typhus."

In the third section of this chapter, the author says, in effect, that when man is attacked by typhus, both man and rickettsia may die, but this will not necessarily prevent an epidemic because fleas or lice may have fed on "the human victim at a time when the Rickettsiae are circulating the blood," and thus continue to spread the disease. As to which of these two parasites is the most tenacious, he says:

> " . . . the louse is by far the more dangerous in relation to epidemic spread; for although, unlike the flea, it can neither hop nor live for any length of time separated from its human host. It possesses qualities of dogged persistence and patient diligence which arouse that admiration, thinly masked by a pretense of loathing, which men similarly feel for competing races whom they fear and therefore persecute."[6]

Through her allusion to Zinsser's book, McCullers emphasizes the idea that the South's "infectious disease" (racism) will not end

with a single legal ruling promoting fair housing practices because enforcement of this ruling will depend on the attitudes of the people, and prejudice is a tenacious parasite, requiring time to eradicate.

This point is so important that the element of time is in focus throughout the play, so much so, in fact, that Evans calls it a minor theme.[7] He means, of course, in terms of the theme he perceives McCullers to be developing. But in terms of McCullers's theme, the characters' perspectives toward time reflect their attitudes toward change. To emphasize her point, McCullers focuses on it in small ways within the action of the play. Mother Lovejoy, for instance, hires a limousine (symbol of privilege) so she will be sure to get to the station on time to catch a train; Sister had just as soon take a taxicab.

The grandfather clock attracts the attention of Phillip and Mollie. Mollie winds it, but Phillip hates clocks, and this has led to the critical opinion that he associates the passage of time with his failure as a playwright, with his loneliness, and with his inability to use his time effectively.[8] But in the context of the saga, it is because he fears change. He has broken his ties with his mother, lost his power over public opinion, and is in the process of losing his hold over Mollie (who represents the more progressive South). The clock's "tick-tock, tick-tock" enrages him, and he smashes it. McCullers emphasizes the fact that it is a grandfather clock; it represents a time established by his forefathers, who deemed that people should be free, and it reminds him (symbolically) of how his defiance of that heritage has brought him to the twilight of his power. Or at least, it reminds the audience, or is intended to.

In the dialogue which accompanies the action in the scene when Phillip smashes the clock, Phillip paraphrases a poem which McCullers published in 1952 called "When We Are Lost."[9] The meaning of this poem is that when we lose sight of our ultimate goals of Divine Unity and worldly unity, we are lost, for time is on the side of these universal goals, and those who defy them are doomed. Time

and evolution, the poem implies, will win. Phillip does not want to face this idea, so he destroys the face of the clock.

Phillip's final recognition of the fact that he has represented an idea which Mollie will not embrace is shown in his farewell scene with his son, where he gives Paris the only two things he has left to offer. One is a space suit, and the other is a chess set. Paris is pleased to have the chess game, and talks about it constantly, even when the other characters ignore him and talk about something else. It is a symbol of governmental and religious power—a symbol which McCullers established in her first novel, The Heart Is a Lonely Hunter, with Singer and Antonapoulas playing chess. The space suit is a symbol of the area of the South over which Phillip has had some control. Paris looks at the space suit and complains that it is small, a "midget space suit," but this is because the "space" which Phillip's power (as a segregationist) in the South now occupies has dwindled.

While the realistic and parabolic levels of development of McCullers's saga deal with a transitional period during which the political climate in the South is changing as a result of legal action, the religious allegory in this play deals with a transitional period in the history of man's search for spiritual harmony. McCullers's previous novel having progressed as far as the Reformation, this drama in the religious allegory begins as that movement gains strength, continues as it becomes part of the ecclesiastic fight to retain sovereignty against the forces of secularism and state sovereignty, and concludes with a delineation of the forces of rationalism which changed the whole direction of religious history. At this point in her development of the allegory, McCullers's images and allusions deal only with those aspects of history which lead toward American involvement, for her aim is to indicate how, eventually, religious spirit and political principle will combine in the American dream to fulfill the Judeo-Christian dream of peace, justice, and freedom.

Within the parameters of the religious allegory, the symbolic function of the characters is indicated imagistically. Mother Lovejoy

represents the mother church. Her ideas are orthodox and formal, representing the powerful tradition of organized Catholicism. But considering the relatively minor role of Catholicism in the early growth of the new world, it is possible that she plays a dual role in the allegory, standing not only for the ecclesiastic force of the past, but also for the Lutheranism which constituted its newest and strongest branch as the foundation of Protestantism. She did, after all, buy the new apple farm where the action of the play takes place; it is not her home (which is associated with peach trees). If my assumption is correct, then the allegorical significance of Sister's having fallen in love with a man in the "Z" section of the library probably refers to Sister's representing the followers of Zwingli, for he was, like Luther, a religious reformer. His opposition to both fasting and the veneration of saints is echoed in references to Sister's voracious appetite and her defiance of southern social customs.

Following both Luther and Zwingli, and having more to do than either of them in terms of the new world was Calvin, and in the play, Calvin would be represented by Phillip. His fathering of Paris is an indication of the fact that Calvinism contributed significantly to the future. However, Phillip's marital relations suggest gradual weakening of his power and influence. Mollie divorced him the first time because he disregarded her rights as his wife and pursued his own pleasure (adultery) which represents an image of the doctrine of the elect, but in general, the first divorce alludes to the failure of the church to hold a dominant position in the lives of men. By the end of the sixteenth century, internal strife combined with social and economic forces had weakened the church to the point that state sovereignty had become a fact.

Phillip's beating Mollie, which contributed to their divorce, appears to allude to the situation of the early seventeenth century, when men had become disillusioned with the persecution and neglect of a church which had for centuries sought to strengthen itself at the expense of the people.

The decisive moment in Mollie's relationship with Phillip occurs when she finally admits that she is tired of love "in a briar patch" and is ready to be practical, which suggests man's shifting intellectual perspectives concerning the nature of God and man in the age of rationalism.

John Tucker is a symbol first, of the national sovereignty which superceded religious sovereignty by the end of the seventeenth century. He is an architect, and his profession links him symbolically to the Baroque style which is associated with this period. He is also a symbol of the new age of rationalism. The opening lines of the play are spoken to Paris (by his mother) in the context of his having a nightmare, but Mollie's exact words are "Wake up, darling," which introduces the major allegorical theme: the growing awareness of humanity.

Paris, who is often called "Lambie" in the play, symbolizes the idea of the living Christ child, and he objects strenuously when John, the stranger, puts his arms around Mollie. But this embrace is an image of the new view of man developed by intellectuals of the seventeenth and eighteenth centuries, a view which held man responsible for himself. John was attracted to Mollie because of her independence. When they first met, he said, "the pulse and color of life returned."

The religious allegory in this play ends with the age of rationalism. Rejecting the physical attraction of Phillip (since he violated her rights) and the support of Mother Lovejoy (the mother church), Mollie leaves the farm with John Tucker, who will build a new house for her and her son Paris, a house which, it is promised, will be practical, and designed for living.

As the play ends, the stage is figuratively set for a marriage of past ideals and present circumstances. As the three of them depart, John talks with Paris about the meaning of love and humility, for these are imperative to the shaping and implementation of law. Paris, whose Christian name associates him with the ideals of the French revolution (liberty, equality, and fraternity) and whose nickname

"Lambie" links him to Christianity, represents a future which is predicated on law as it is shaped by the union of political and spiritual ideals.

<div style="text-align: center;">

6

</div>

CLOCK WITHOUT HANDS

The furious intellect relating furtherest space to
 beyondest time,
Exalting abstractions, vaulting the 1 2 3,
Defaulting from the simplest kinship, disjoining man
 from man,
Seeing across oceans, and stumbling on a grain of sand.

— Carson McCullers in "The Dual Angel"

"The whole earth from a great distance means less than
one long look into a pair of human eyes."

— Carson McCullers in <u>Clock Without Hands</u>

This novel is the story of four people who live in the small town of Milan, Georgia. They are all male, which represents an interesting departure from McCullers's usual mixed cast of characters with females generally dominant—and is significant, as will be seen. J.T. Malone is a pharmacist who is diagnosed with leukemia and is worried about dying. He seeks solace from his friend, Judge Clane, a former Senator, the town's most respected citizen, who clings determinedly to the ways of the Old South, but is concerned because his grandson does not. The boy, Jester, is a teenager who is lonely and unsure of himself, as is seen in his relationship with a friend, Sherman, a young black boy who is trying to establish his teenage identity as well.

The theme has been seen as a search for self-knowledge and identity,[1] which clearly seems to be a major focus of the book. The

problem is that the story line jumps from an emphasis on one character to another without much sense of connection, and the younger characters' dilemmas seem unrelated to those of their elders. This has led to charges of serious flaws in the artistic structure of the novel: it has been described as "loose" and "confusing,"[2] and its technique does not appear to some readers to fit its subject matter.[3]

A good deal of that subject matter deals with race relations, with bigotry well defined, prejudice flaunted, and violence committed openly on the streets. This has led to condemnation of the work for its "heavy-handed moralizing" which makes it seem to some almost mechanical."[4] "The result," says a noted scholar, "is not a novel but a tract....The book is not 'about' human loneliness in the guise of segregation, but 'about' the segregation issue itself, and the race question is not a symbol of an underlying cause, but the specific cause."[5]

These changes are justified if the novel's theme is seen as loneliness or segregation, but in fact, it is about neither: it is about communication and integration, and this distinction is important because it means that the focus of the novel is on the solution rather than the problems.

The reason that racism and segregation are prominent in this novel is because the possibility of legally mandated school desegregation is imminent, and since that is, implicitly, a fact known to all the characters in the book, it shapes the action and indicates the theme. The focus of the action is on how the characters, both black and white, will be able to communicate with each other successfully when forced to see each other from a different perspective. This focus is introduced in the opening chapter, symbolically, when Malone learns he is ill. This changes his perspective; he must now not only communicate with others he's had no interest in before but must learn how to do it effectively.

The Court's decision was made in 1954, and is made known at the end of the novel, as Judge Clane reacts to it in his radio broadcast. But on the realistic level of development of the novel, time

in <u>Clock</u> is 1953, the year during which integration was a national focus because everyone knew that the Supreme Court was debating whether or not the long-held doctrine of separate-but-equal schools (for black and white) was constitutional. During the main action of the story, the outcome of that debate is not known, but what happens in the story is predicated on the fact that there is a strong possibility that soon school integration will be mandated throughout the United States. The characters are defined in terms of their reactions to this possibility, and on the realistic level these reactions reflect their concerns about how it will affect them personally; on the level of development of the political parable, their response indicates a shifting of political power to a generation more aware of human rights. The religious allegory suggests a shift toward greater personal responsibility with respect to matters of conscience.

In the parable, it is clear that Judge Clane represents conservative southern views. An advocate of white supremacy, his language is full of the bigotry associated with it, and his attitude toward and treatment of both Sherman (a young black man) and Verily, his black housekeeper, is arrogant and disrespectful. The power of that segment of white southern thought which he represents at the beginning of the story is indicated by both his prominence in the town and his close association with J. T. Malone, a respectable businessman.

This association is very close because it not only shows the Judge's social status but helps establish Malone's symbolic identity. The Judge is a former Senator; Malone, like Singer in <u>The Heart is a Lonely Hunter</u>, is a symbol of government. Like Singer, he walks the streets of the town alone, and seldom talks with anyone he meets. He wants to talk, but no one approaches him. His main contact is with the Judge who is a former politician. They are friends because their (political) perspectives are similar. Malone is a pharmacist who thinks that old remedies are best. Like Singer, Malone is introduced in the opening chapter of the novel, where his (and government's) problem (like that of his fictional predecessor) is suggested in the

form of an image. In <u>Heart</u>, the image was of silence and lunacy (as no word was spoken, and the central action involving religious and political ideals was indicated in the craziness of Antonapoulas). In <u>Clock</u>, the image is illness and confusion. As a symbol of government, Malone is faced with the fact that he is physically ill (implying trouble with voter support) and he is confused because he does not quite understand what is wrong with him. Symbolically, he has leukemia (which is characterized by the presence of too many white cells in the bloodstream—which means that he is being dominated by the white South). Indeed, the Judge does make demands on him, and although at first this does not seem to bother him since he values the old man's friendship, his feelings about it change after he knows he is physically sick for then he needs to make demands of the Judge, and when he does, the advice and opinion he gets do not seem to help. It begins to appear that he may die as a result of his condition, which, in the parable, would (and does) indicate the end of southern separatist political power in the Federal government.

Representing a government which has for all practical purposes ignored minorities before, Malone is suddenly forced (because of his condition) to consider them in relationship to himself when his doctor, who is a Jew, tells him he is ill. He had known this doctor for a long time, and thought of him as a friend, but suddenly when the doctor tells him he is dying, he is resentful, so he changes to a Gentile doctor. He is now aware, however, of the Jew as a force with which he must deal, and soon he becomes aware of another minority, the Black. As he walks by an alley he is frightened by a shadow which appears to stalk him. Turning, he sees a young Negro with blue eyes. Malone, who thinks he has always been lenient in his views toward Negroes, is thrown into a panic because the figure seems grotesque and threatening.

This figure is, of course, Sherman Pew, who in the parable represents that segment of the black population which is filled with hope and anxiety as it awaits the Supreme Court decision. Malone does not see him clearly because (within the parameters of the

parable) he (as government) has not previously identified the presence of a black constituency as a political threat. Memory of his encounter with the shadowy figure of Sherman haunts Malone after his encounter with the black man who was (as is suggested by his blue eyes) beginning to think it possible that he might see the world from the perspective of a Caucasian who expects the government to guarantee his rights. Malone does not know how to deal with that.

Neither does he know what to think of Jester Clane, for he does not understand him. Jester represents the new South, which objects to the status quo and is groping for a way to reconcile its love for the region with its moral commitment to what the nation stands for. While he avoids Malone, he openly clashes with his grandfather on the subject of segregation. He questions "the justice of white supremacy" and defends his right to disagree with his reactionary kinsman.

The boys thus cause the Judge and Malone to feel insecure, to realize they are losing their power. The Judge can no longer make his grandson obey him and Malone is losing control over his life. As a result, the Judge becomes obsessed with trying to recapture the past as, for instance, he searches for a woman like Miss Missy, his now dead but beloved wife who represents the "old South." He needs support. Malone turns to literature and philosophy (while in the hospital) and then goes home, where people care about him, and he can rest and ponder his dilemma.

At the end of the story, Judge Clane plans to make a speech against school desegregation, but when he gets to the radio station, he recites Lincoln's Gettysburg Address instead, which realistically makes little sense except to suggest that he has become mentally confused, or senile, but it conveys McCullers's message imagistically. The southern bigot is now performing in a socio-political climate which recognizes the total lack of logic in his oratorical excursions: although he quotes Lincoln's words, he publicly admits that the principles they convey are not what he meant at all.

Malone dies at the end of the novel, specifically on May 17th, the day the Supreme Court handed down its decision. His death does not mean the demise of government; it means the end of a government too greatly influenced by the segregationist South. Malone is a family man, however, which means that he represents just one member of a group which symbolizes government. He is the member who had most power in the past. But during that time (when he and the Judge were so close), Malone was estranged from his family. In fact he was unfaithful to his wife. A minor character in the story, little is known about her except that she inherited the pharmacy from her father, and had bought shares in the Coca Cola company during the thirties. But these two facts suggest that she represents both capitalism and confidence in American ideals, for the pharmacy replaces the various other symbols which have been used in the saga to designate the "paternal edifice," such as the country store in <u>Ballad</u>. A pharmacy is more logical in the nineteen-fifties because America has become more scientifically and technologically oriented. Implicitly, Malone's wife will have charge of the pharmacy (the establishment which serves the people), and also implicit is that her daughter may eventually inherit it from her. Little is known about the daughter except that she is secretly in love with Jester Clane, and this would appear to be insignificant since he hardly knows that she exists. But that is because he is still a boy, and immature. In terms of the parable, he does not yet know enough about himself to know to what extent he will commit himself to his ideals in a practical way. McCullers leaves the question as to whether they will marry open, for at the time of the writing of this novel, there was no assurance that even liberal Southerners would actively support integration. But with her inclusion of the character of Malone's daughter in the story, she suggests that it is possible.

Having brought her religious allegory up through the eighteenth century in <u>The Square Root of Wonderful</u>, McCullers deals with the 19th and 20th centuries in this novel.

Both its structural design and its character grouping provide a basis for contrast between the two periods. There are fourteen chapters in the book, and the two that mark the division between the two centuries are chapters seven and eight, which lie at the exact center of the work. Throughout the six chapters preceding these two, the church is prominent in several ways, reflecting the fact that religion was a dominant aspect of nineteenth century life and thought in the American South. During the time of these chapters, both Judge Clane and J. T. Malone attend church regularly, which suggests that formalized religious service is still firmly entrenched. Judge Clane quotes biblical passages frequently, and Malone seeks spiritual guidance from the clergy relative to his concerns about death.

But decline in the power of the church is indicated as well. It is seen not as a place of worship, but as a means of attaining personal or social goals. While the Judge can be seen in his pew every Sunday, he is not there to save his soul but to search the choir for an amply endowed woman to take his beloved wife's place; and when at home he quotes the scripture, it is to make a joke. Malone's motive for going to church has been because it has extensive financial support and has attracted the most prominent men in town to its congregation. Apparently he has never paid much attention to the sermons because suddenly, when he needs spiritual guidance and help, he begins to think about them and becomes disillusioned because they do not offer the answers he wants. At first he is simply puzzled as to why he can find no solace from the sermons, but as his need becomes more urgent, he decides he must have more specific answers, so he visits the preacher. However, when he asks for elaboration on what the preacher has said in church about the soul, afterlife, and righteous living (as preparation for death), the preacher is evasive and merely offers him a coke. The church appears to have more concern with worldly matters than with spiritual ones.

In Chapter 8, Malone does find some answers in a book he reads while in the hospital. This chapter marks the turning point from

the nineteenth to the twentieth century (in the imagistically developed religious allegory). The church is not mentioned in the last half of the book, which suggests a decline in its influence during the first half of the twentieth century and a transition toward humanism.

In Chapter 7 (the other of the two chapters which mark the mid-point of the novel) this transition is clearly defined in what might be called mini-parables associated with Jester and Sherman. Jester procures a jar of caviar to give to Sherman as a symbol of his love. When they meet, however, Sherman is being so obnoxious he doesn't give it to him. When Sherman begins to describe how he was mistreated as a child, however, Jester is so overwhelmed with sympathy that he leans over and kisses Sherman. This precipitates a fight between them, but what caused it is soon forgotten, as they get involved in a debate about ethical conduct. Later, when Jester gets home, he opens the caviar, but it smells so fishy to him he won't eat it. Neither will the Judge or the maid, Verily, so he gives it to the yard man who, it is said, will eat anything. Since the caviar was originally a symbol of Jester's love for Sherman, and fish is a symbol of Christian love, the episode is intended to suggest that in a twentieth century context, relations between men are better served through physical expressions of love (the kiss) and intellectual discussion (about ethics) than through symbols (such as the church). Jester, in fact, is totally disassociated with the church, exemplifying an attitude toward it that is becoming observable within the white population in the twentieth century. He never attends church. He flies his plane on Sunday mornings, something that would have been totally unacceptable in the nineteenth century South.

While Jester is thus used to evoke an image of shifting social and intellectual perspectives relative to the church, Sherman serves to indicate a moral flaw within the church: it perpetuates racial divisiveness (as opposed to spiritual unity). This idea is conveyed by a little story he tells. He says that when he was in France, he met a white girl and they planned to get married at "an old church called Notre Dame." Jester corrects him, saying it is a cathedral. Sherman

responds that it does not matter what you call it, for the principle (he implies) is the same. The principle is that churches should not make distinctions between people based on nationality or skin color. In France they did not. In the American South they did.

The point is emphasized by another of Sherman's allusions to the church. He hates spirituals. In Sherman's church, spirituals are sung, whereas in the white church, hymns are sung. The point is that since the church itself is responsible for what kind of music it employs, it is contributing to racial divisiveness.

The emphasis on linguistic distinctions (caviar/fish, church/cathedral and spirituals/hymns) in connection with the two boys' roles in the religious allegory is not accidental. One configuration deals with church symbolism, another with church appearance, and the other with church ritual. This resembles McCullers's three plus one formula with a fourth implied: church message. As was seen in connection with Malone's search for meaning in the church, the message was missing, but he later found one in a book. The book associated with the church is the Bible, so a fourth configuration is book/bible. Each configuration is composed of two terms, one worldly in connotation and one spiritual. But in the fourth, one term is implicit only if the other three configurations are recognized within the parameters of the mathematical paradigm to represent three levels of worldly completion with one (the fourth) missing. Then the missing part of the fourth is seen to represent what is needed: the Bible. So McCullers's message within the religious allegory is that what is needed in the twentieth century is for the church to clarify God's message as it relates to man's shifting needs and to demonstrate its own spiritual commitment by practicing what it preaches.

Both the religious allegory and the political parable thus focus on the theme of self-knowledge and identity, as these levels of the novel's development indicate that both church and government are figuratively ill because neither is functioning within the parameters of their historical principles and ideals.

On the narrative, or realistic level of development, the novel focuses on how the people in the south are reacting to the possibility of a mandate to integrate the schools. Judge Clane is predictable. As an old man and a politician, he is well aware that his way of life (the southern heritage of white supremacy) is being severely threatened. After all, his own son had, some years earlier, actually defended a black man in court over his protests, and now his grandson is openly attacking his convictions. He clings to the hope, however, that maybe he can swing the younger generation over to his side with gentle persuasion (it is only at the end that in desperation he resorts to public oratory) so he plies his grandson with traditional southern Sunday dinners of fried chicken and biscuits and keeps an image of the Old South, romantically portrayed, in front of him in a picture hanging in the living room. When Jester tells him flatly that he does not see it (the picture/the south) the same way his grandfather does, the Judge is upset but does not give up. He decides he will make a concession to those who disagree with his view that black people are inferior and show them that he is fair minded: he will hire a black boy to be his personal secretary, and he will call him his amanuensis to make it appear that this is an important position. The plan backfires, of course, for although he indulges the boy (Sherman), giving him extraordinary privileges in the house, he eventually slips up and shows Sherman exactly how bigoted he is. Meanwhile, the boy is learning how it feels to be white and afford such luxury, and taking advantage of the old man's indulgences, learns self-assertiveness which will later lead to his finding the strength within himself to defy all that the Judge stands for. At the end, Sherman moves into a house of his own in a white neighborhood. Furious, the Judge gets a gang of rednecks to kill him, but this act signals the end of his power in the South, for he no longer has the friendship and support of respectable people.

Malone is a businessman, and ill as well, so while he is implicitly aware of the debate which is occurring in the Supreme Court, he takes little interest in it. He is mostly preoccupied with himself and

his pharmacy. But that is important, because the conclusion of the debate will force individuals and business to make decisions as to how they will deal with the Court's decision.

Although Malone does not appear to consider this in specific terms, it seems clear that it is on his mind, for throughout the story, he keeps thinking of Johnny Clane, the Judge's son. This son, when in his father's courtroom, defied him by trying to save a black man from being sentenced to die for a crime he did not commit simply because he was black. When, at the end of the novel, the Judge "holds court" over a "jury" of white bigots in Malone's pharmacy, Malone refuses to help them kill a black boy simply because he is black. The middle class, it is suggested, will not kill, but will make no effort to stop others from violence.

The hard question posed by the impending court decision, however, is how a desegregation mandate will be received by those most affected by it, the young, and so the two boys are the main characters of this novel. Through what appear to be sometimes bizarre situations, McCullers explores the psychological problems that these boys have as a result of having grown up in a Jim Crow South.

The episode which involves Jester and Sherman's meeting is one of these situations. McCullers describes the action as if it concerns nothing extraordinary, but, of course, this is exactly McCullers's point (that it should be considered extraordinary).

Being lonely one night late, and hearing some jazz music, Jester simply leaves the house, locates its source in a house in the lane nearby, and knocks on the door. Inside he finds Sherman Pew. While this little bit of action is slight in terms of the novel as a whole, its implications are relevant to what follows in terms of the boys' relationship and behavior thereafter. Jester knew the houses in the lane were occupied by Negroes, and that is why he did not hesitate to knock on the door. His action represents a monstrous lack of respect, for no white man would knock on the door of another (unknown) white man's house late at night and invite himself in,

simply because he liked the sound of what was going on inside. With this incident, McCullers indicates that in Milan, Georgia, in 1953, even those white persons like Jester Clane, who might rhetorically defend the rights of black people (as Jester had just done in his argument with his grandfather) still harbor unconscious attitudes of superiority which are deeply ingrained in habitual behavior which their actions betray. Jester's rudeness was unintentional, but it was born of racial discrimination practiced long and without thought.

Considering that Sherman was aware of this, his hospitality shows remarkable restraint and sensitivity, but knowing that his visitor is there only because he assumes that his being white gives him the right to intrude makes Sherman very nervous and insecure. While excited at the prospect of making a friend of this socially prominent white boy, Sherman is afraid that he will not live up to expectations as being worthy of such an acquaintance and so he vacillates between cordiality and hostility, trying to impress on the one hand and defend on the other. The effect is like that of an angler, pulling hard to maintain control, but giving line to hold the victim in tow. It would be a victory for him as a person to become friends with a white boy, but everything in his cultural history reminds him that he would be a fool to trust the white man, as Jester's entry has just confirmed.

When, later in the story, Jester brings some presents to Sherman (to show his love for him) Sherman rejects the gifts. Jester does not understand why, but it is because traditionally, in the South, Whites had shown condescension toward black people by giving them gifts (clearly expecting none in return). Sherman is humiliated and frustrated. He does not want to be patronized. He wants to be a friend, and friendship is based on respect.

It occurs to Sherman that one reason he is not seen as an equal by these white people who seem to like him is that they are a family, and he has no real family because his mother abandoned him when he was a baby. So apparently to give himself some self-confidence, he invents a family which he brags about constantly, though its

members do not appear in the story. But he knows this family is a fiction, and so in all his encounters with white people he is constantly on his guard not to betray his sense of insecurity. This results in his constantly trying to prove that he is superior to Jester (which, of course, Jester does not understand}, and which defeats his hope of real friendship.

Family is a factor in racial attitudes in the South for it represents one's social and political heritage. Even if Sherman had known who his mother was, he would still be stuck with a feeling of social inequality and perhaps worse, a racial stigma. Since his mother had left him in the church as a baby, the implication was that she was poor and dependent on society for support. Even worse was the possibility that she may not have been able to keep him because his conception might have been the result of rape—of a white man's having taken advantage of his mother and her lack of protection under the law. This thought being intolerable to him, and most especially at this time, when establishment of black rights under law seems so near, he invents a mother for himself to impress Jester.

Because the only white people who had shown an interest in him did so because he had an interest in music and was musically talented, it occurs to him that his real mother may have actually been extraordinarily talented and have had to abandon him in order to pursue her career—which is more socially acceptable than what he had previously assumed. So he provides himself with an imagined mother from whom he decides he must have inherited his musical talent. He chooses Marion Anderson, a black singer who had become so respected by Whites that she had become famous for having held a concert at the Lincoln Memorial. Convincing himself that she must be his mother, Sherman feels pride in his heritage, and this gives him the confidence to deal with the scary business of trying to prove himself equal to the southern white people who for so many generations have treated his race as inferior.

But when, at the end of the story, he learns that it was his mother who was white and his father who was black, he is devastated. The

reason is that all his life, because of his blue eyes, he has assumed that his father was a white man and that his mother had been forced to submit to his whims. Sherman's hope, based on his fantasy, that his mother eventually got revenge by becoming someone like Marion Anderson, who in spite of her youthful humiliation at the hands of the white man had through her musical talent risen to command the respect of both white men and black, is shattered. If his parents' racial roles are reversed, the implication is that his father, a black man, had been seduced by a white woman, thus betraying both his manhood and his race.

Wild with anger and humiliation at first, Sherman decides that he will be the man his father was not and make white people respect him. He moves into a white neighborhood and buys a piano to assert his manhood.

Evans sees Sherman's behavior as too "outré" to be credible on realistic terms and not sufficiently so to be a genuine grotesque,"[6] but within the context of the novel's exploration of the state of mind of black and white youth under the pressures of the time, Sherman's thinking is psychologically accurate and artistically rendered. As Richard Wright said, McCullers's work demonstrates "the astonishing humanity that enables a white writer, for the first time in southern fiction, to handle Negro characters with as much ease and justice as those of her own race."[7] Evans's problem (on this point) is first, that he sees the theme as segregation (rather than need for integration) and second, that he does not recognize the narrative point of view in McCullers's work. He seems to see Jester, too, in terms of his being merely a young man whose "inherent liberalism is strengthened by the knowledge that racial injustice has been partly to blame for the tragedy of his father's life, and he resolves to become a lawyer himself and take up the battle where his father left off: his life thus achieves moral direction."[8]

This may be true, but it is not the main point McCullers makes about this character. McCullers's concern is with the psychological barriers that impede racial harmony.

In a sense, Jester's dilemma is as great if not greater than Sherman's. He is an idealist with a strong sense of right and wrong and an unshakable belief in justice and equality. Simply, he does not know how to translate his ideals into reality. Ironically, his grandfather accuses him of having no passion, when it is this very trait that causes him to blunder. He rushes in to do the right thing without considering the consequences, and the result is that he does it the wrong way or with the wrong consequences or both. He operates by means of his heart rather than his head (for he is a literary descendent of Mollie in The Square Root of Wonderful, who loved too much) and as a result, although he is the one white character who is most concerned about racial equality, it is he, not the bigots, who is essentially responsible for the deaths of two black persons.

In the first case, a young, hungry black boy steals some money, and Jester chases him down the street, not realizing that because he (Jester) is a member of the white aristocracy, every mill hand in sight will follow, taking up the hue and cry. The black boy is killed when an overzealous policeman joins the mob. In the second case, Jester knows that a group of white men plan to bomb his friend's house and he goes to warn him (Sherman), but this is childish: it is thoughtless reaction. The mature reaction would have been to openly defy this group or to have called the police, both of which he would have done if a white man's life were being threatened. He did neither. His silence was as immoral as their action, and in effect, far more devastating, in McCullers's view, for he failed to stand up for what he knew was right.

Further, in his effort to convince Sherman of his love, he allows himself to be treated by Sherman like a doormat. He is so afraid of hurting Sherman's feelings that he treats him like someone special, when what Sherman wants and needs is simply to be treated as an equal.

Jester never understands this, but an episode at the end of the novel suggests that he has matured slightly. It occurs after Sherman's death, when Jester takes the man who killed him, Sammy Lank, for

a plane ride. Jester's plan is to kill Lank, but at the last minute, he looks into Lank's eyes, and changes his mind. This has been interpreted to mean that "by trying to know" Lank, he "makes peace with the turbulent world,"[9] and perhaps so, though I think McCullers is simply trying to make the point that respect for others comes from recognition of their rights as human beings.

In any case, Jester is not the main character. Malone is. The story begins and ends with him. He is the hero, in the sense that he is the one who changes and matures. Ironically his change is shown physically as illness and death, but in the political parable, he is a symbol of government which in the early pages of the novel is shown to be dominated by politicians like Judge Clane, who represents social and economic elitism and bigotry. At the end of the novel, Malone dies because that era in American politics is ending, but his wife, who has a vested interest in the future of America (symbolically, through her Coca Cola stock) will take over—and later, it is implied, his daughter will marry Jester (symbolically bring the still uncommitted South back into the union). The novel is optimistic, and ends with a reminder of the Gettysburg Address.

Readers appear not to have recognized Malone's symbolic role in the novel, and this fact may account for critical opinion that the artistic structure of the work is "loose and confusing"[10] and "its technique does not seem to fit its subject matter."[11] But whatever the reason, the fact that the book is seen as being artistically flawed and to resemble "a tract"[12] rather than a work of art has led to its having lost its appeal for readers. The book is now out of print, and this is unfortunate, since it is the epiphanal work of the saga, with all that this function entails in terms of providing closure to theme and design.

The title of this work has no doubt been seen as a reference to the supposed main theme of the novel because it is so obvious that it refers to a time (when integration is mandated) when the mandate will not have the support (hands) of the people. But it is more complex than that. Chapter 7 will discuss McCullers's designs.

7

CONCLUSION

Before the full extent of McCullers's literary accomplishment can be known, the artistic designs in her work need to be explored further. Particularly is this true with respect to her allegorical and parabolic designs, for my speculations relative to these are at best an educated guess. I am, after all, an English professor, not an expert in either religious or political history. There is evidence, too, that McCullers's metaphorical designs in both music and mathematics far exceed my acquaintance with these disciplines. Even within my own field, there is more to be done. My aim has been simply to define and exemplify sufficiently to make a point.

But it must be remembered that all of McCullers's designs adhere strictly to the formula, and while they may appear in myriad ways they always represent the 3+1.

Names of characters always display the formula. Professor McDonald, who many years ago identified McCullers's theme as need for knowledge, proposed that name symbolism in The Heart is a Lonely Hunter was associated with the Judeo-Christian epos, and specifically linked Brannon to Bartholomew, Blount to Jacob, Copeland to Benedict, and Mick to Michael. This represents the 3+1 formula in terms of the religious allegory, since Bartholomew (according to McDonald) gave up this name out of reverence for Christ"[1] and thus is the "one" who differed from the others.

However, Brannon himself has four "names" or identifications. He specifically thinks of himself as "Bartholomew old Biff with two fists and a quick tongue—Mister Brannon—by himself" in the closing sentence of Chapter 1 of The Heart is a Lonely Hunter. We know that the Christian name, Bartholomew, alludes to the religious

allegory. The nickname "Biff" appears to associate him with the hero of popular movies produced during the thirties starring Jimmy Cagney, whose dramatic personae was often "Biff." Thus it indicates that he is a "fighter" by nature, and relates him to the political parable as a person whose inclination to act aggressively on his feelings is strong. But as "Mister Brannon," he is defined as a man who is trapped by social convention. As "himself" we are provided with an allusion to his personal inclination to want to escape the shallow parameters of his life. When he is left "by himself" (after his wife dies) he decorates his room (not considered a "manly" thing to do at the time). The formula is 3+1: he has the will to act, but is thwarted by social/religious/political convention. His strength is indicated by his last name, Brannon. He is the "bran" not the "chaff" of society.

But name symbolism in McCullers's novels is not confined to references to her religious and political paradigms. A student of mine at NC State University, Alma Biagini, found evidence that the name "Mick" (in The Heart is a Lonely Hunter) might also be an allusion to Michael Kelly (a notorious follower of Mozart). In McCullers's first novel, great emphasis is placed on Mozart as the favored artist of a central character, Mick Kelly. In the novel, Mick misspells the name Mozart (as Motsart), but the fact that the name is thus emphasized, says Biagini, draws attention to the fact that Mick is listening to Beethoven while she wishes she were hearing Mozart. Ms. Biagini's research indicates that an understanding of McCullers's work requires some knowledge not only of music but of the circumstances surrounding its composition. But even with this much understanding, we can see the 3+1 pattern, for three names associated with music have emerged in the novel (Mozart, Motsart, and Beethoven) and another, outside the novel (Michael) has been associated with the three. Michael is a follower of Mozart. McCullers's formula emerges, suggesting the need for followers (supporters) of those who have brought great harmony to the world.

An understanding of even the simplest things about music is also required to identify some of McCullers's designs, for as the

epiphanal elements in her first novel indicate, her work is like a crossword puzzle with its manipulation of the language—and relative to the music paradigm, we can see there is manipulation of all forms of communication. In The Heart is a Lonely Hunter a music-related design is the basis of artistic structure. There are four main characters, but each is introduced in a separate chapter, and their plot lines seldom cross, but develop linearly and parallel to each other, which graphically depicted (as the Pythagoreans would have insisted on doing it) resembles a musical staff. Singer's profession is creating decorative letters, so if he were to sign his name, the first letter would resemble a treble clef (which is also known, when it appears on a staff, as a Signature). The first letter of Antonapoulas's name is an A, which, written cursively, resembles a bass clef, especially if you erase half of the A, to suggest that Antonapoulas is only "half there" (a term often used in the thirties to imply that someone was crazy). The configuration now resembles a bass and treble clef with four lines given to resemble a musical staff (which represents three parts of a design) but a musical staff has five lines, so there is one line missing.

The title The Member of the Wedding suggests three people—but the story is about the "one" who is not actually a member of it. In this novel, Frankie is constantly talking of "the we of me," which is literally the reverse of the title, so implied is "the I of us," (and an I is shaped like a one). We see similar use of the title in The Square Root of Wonderful. The first syllable of the word wonderful is pronounced "one"—which, since it is a number, relates to the mathematical implications of "square root." What is the square root of one? In McCullers-ese it is "3" (x3) plus "1" more.

The title of the final work of the saga is, like the title of the first one, more complex. Its obvious reference is to the central event of the novel: the Supreme Court decision. It refers to the situation of the novel: a time when racial integration is legally mandated, but not a fact until action is taken to achieve it—action being indicated by the symbol "hands." The title is also epiphanal, directing us to the

first novel of the saga, The Heart is a Lonely Hunter, which McCullers called The Mute. Mutes use their hands to communicate. This reference has been discussed.

But the title is complex in its references. The number 12, which appears on the clock face, refers to groups which have represented religious, political, or social unity in the past, and has also been identified as a number signifying the end of one era and the beginning of another.

But a clock without hands is literally a circle with numbers. What is needed (in terms of McCullers's theme) is a circle (completion) with one number (symbolizing unity): a ten (10). The 10 is the ultimate goal, and McCullers focuses on this number in this novel in myriad ways.

The most obvious, perhaps, is with the word "hands," for they represent 10 fingers. Hands are implicitly used constantly throughout the novel as Sherman's playing the piano is emphasized during the action. The piano is itself a symbol (as part of the musical paradigm) of unity—another word for which is harmony (and in McCullers's work, there is always another meaning for a word implied). The piano has black and white keys, so is a symbol of racial unity. In this novel the piano is played by the black character, but not by his white friend. The focus is on need for "1" other "player."

The image of the clock is a circle; thus it represents completion, or the achievement of integration (unity) by legal mandate. This mandate, the piano symbolism implies, has the support of one pair of hands, Sherman's. What is needed for the clock to have meaning is another pair of hands (which the clock lacks) signifying unity, and the word clock itself conveys the idea in terms of one of McCullers's favorite ways. The word has a "k" signifying knowledge, or unity. It has one number ten (10) in it (via the 1 and the 0). Two c's joined together form another "0" so what is missing is the one (another 1) to make that second 10. McCullers apparently wants to make sure that we notice this aspect of the title because she presents us with a clever little example of it near the end of the book.[2] The episode

where this occurs is a brief encounter between Sherman and Jester in which Sherman's determination to fight for his rights is shown in contrast to Jesters's feeble declaration of love, which Sherman ridicules and then tells Jester he needs to "do better" (than simply declare his commitment)—he needs "to move." But in this conversation, the word "cockles" appears six times in the space of four lines and is followed by Sherman's "pounding on middle C of the baby grand piano." The message is that the number ten (6+4) is needed in the form of 10 white fingers working to make harmony. The "C" which Sherman pounds is symbolic of harmony half completed, and requiring the other half for closure. The white pair of hands is the one (1) thing needed to provide unity and completion.

It is ironic that this author's work has been so maligned for what appears to be disunity, when it is, in fact, incredibly tightly controlled. Even the titles of her works, both separately (in diverse ways) and together, evoke the point of the saga. The dominant vowel in The Mute (the title McCullers gave her first novel) is a "u." In Ballad it is an "a." In Member it is an "e," and in Square Root it is an "o." But there are five vowels (a,e,i,o,u), so it would appear that since the "i" is missing (for "i" is not the dominant vowel in Clock), the presence of the other vowels in the other titles is mere coincidence. Appearances are always deceptive in McCullers's work, because she is a realist. The absence of the "i" in the last novel's title is intentional, the purpose of which is to draw attention to the "I" (the one) who is missing in all the works: the reader who, armed with the tremendous amount of knowledge of history, religion, literature, mathematics, philosophy, politics, art, and music which McCullers has just provided him with, will act to create unity in his world and with his God. In unity lies freedom.

ENDNOTES

Chapter 1

1. Louis D. Rubin, Jr. "Carson McCullers: The Aesthetic of Pain," Virginia Quarterly Review, 53 (Spring 1977) 268.
2. Oliver Evans, The Ballad of Carson McCullers (New York: Coward-McGann, 1966) 192.
3. Nancy B. Rich, "The 'Ironic Parable of Fascism' in The Heart Is a Lonely Hunter," Southern Literary Journal (Spring 1977) 108.
4. Leslie Fiedler, Love and Death in The American Novel, (Cleveland 1962) 453.
5. Chester F. Eisinger, Fiction of the Forties (Chicago UP Chicago) 251.
6. Jan Whitt, "The Loneliest Hunter," Southern Literary Journal (Spring 1992) 33.
7. Lorine Pruette, "Book Review Section," The New York Herald Tribune, June 9, 1940) 11.
8. Richard Wright, The New Republic, (August 27, 1940) 195.
9. Clifton Fadiman, The New Yorker, (June 8, 1940) 69.
10. Lewis Gannett, The Boston Transcript, (June 5, 1940) 13.
11. Irving Malin, New American Gothic (Carbondale, Ill.: Southern Illinois University Press, 1962) 113.
12. Ihab Hassan, Radical Innocence (Princeton: Princeton University Press, 1961) 215.
13. Dale Edmonds, Carson McCullers (Austin: Steck-Vauglin, 1969) 9.
14. Rubin, 270.
15. Evans, 40.
16. Sue B. Walker, "The Link In The Chain Called Love: A New Look at Carson McCullers's Novels," Mark Twain Journal, Winter 1976-77) 8.
17. Frank Baldanza, "Plato in Dixie, Georgia Review, 12 (1958).

18. C. Michael Smith, "A 'Voice In a Fugue': Characters and Musical Structure in Carson McCullers's <u>The Heart Is a Lonely Hunter</u>," <u>Modern Fiction Studies</u> 25 (Summer 1979) 258-62.

19. Edgar McDonald, "The Symbolic Unity of <u>The Heart Is a Lonely Hunter</u>" <u>Festshrift for Professor Marguerite Roberts</u> (Univ. of Richmond Press, Richmond 1976) 168, 185.

20. Barbara Farrelly, "<u>The Heart Is a Lonely Hunter</u>; A Literary Symphony" <u>Pembroke Magazine</u>, 1988, 16.

21. Jeremy E. Pollock-Chagas, "Rosalian and Amelia: A Structural Approach to Narrative," <u>Luso-Brazilian Review,</u> 12 (1974) 263-64.

22. Kenneth D. Chamlee, "Cafés and Community in Three McCullers Novels," <u>Studies in American Fiction</u> (Autumn 1990) 233-240.

23. Oliver Evans, <u>The Ballad of Carson McCullers</u> (New York: Coward-McGann, 1966) 195.

24. Author's Note: "Reflections in a Golden Eye" is not part of McCullers's saga. She described it as a "fairy tale" and freely admitted that she had written it "simply for fun." Carr, 90, 91.

25. Joseph R. Millichap, "The Realistic Structure of <u>The Heart Is a Lonely Hunter</u>," <u>Twentieth Century Literature</u>, (January 1971) 14

26. Carson McCullers, "Letters and Miscellany," Box 2, Item 21-22, McCullers Collection, Humanities Research Center, University of Texas, Austin.

27. Edgar McDonald, "The Symbolic Unity of <u>The Heart Is a Lonely Hunter</u>," <u>Festshrift for Professor Marguerite Roberts</u> (Univ. of Richmond Press, Richmond, 1976) 185.

Chapter 2

1. Carson McCullers, "Author's 'Outline of <u>The Mute</u>'" in Oliver Evans's <u>The Ballad of Carson McCullers</u>, (New York: Coward-McCann, Inc. 1966) 195.

2. Frank Durham, "God and No God in <u>The Heart is a Lonely Hunter</u>," <u>South Atlantic Quarterly</u> 56 (1957) 495.

3. McCullers, "Outline" 195.

4. John Bright, <u>A History of Israel</u> 2nd ed. (Philadelphia: Westminster Press, 1976). All references to the history of Israel throughout the current text are predicated on the author's interpretation of the chronology in Bright's book.
5. Bright, 359.
6. Patricia Box, "Androgyny and the Musical Vision: A Study of Two Novels by Carson McCullers," <u>Southern Quarterly</u> XVI (Mississippi: UP Southern Mississippi January, 1978) 123.
7. Ihab Hassan, "Carson McCullers: The Alchemy of Love and the Aesthetics of Pain," <u>Modern Fiction Studies</u> 5 (1959) 317.

Chapter 3

1. Oliver Evans, <u>The Ballad of Carson McCullers</u> (New York: Coward-McCann, 1966) 131, 143.
2. Evans, 136.
3. Jeremy E. Pollock-Chagas, "Rosalina and Amelia: A Structural Approach to Narrative," <u>Luso-Brazilian Review</u> 12 (1974) 263-64.
4. Janice Townley Moore, "McCullers's <u>The Ballad of the Sad Café</u>" 29 (November, 1969) 27.
5. Robert S. Phillips, "Painful Love: Carson McCullers's Parable," <u>Southwest Review</u> 51 (Winter, 1966) 81.

Chapter 4

1. Klaus Lubbers, "The Necessary Orders: A Study of Theme and Structure in Carson McCullers's Fiction," <u>Journal of Aesthetics</u>, VIII No. 8 (1963) 196-7.
2. Virginia Spencer Carr, <u>The Lonely Hunter</u> (New York: Doubleday 1975) 195.
3. Carson McCullers, "Letters to Reeves," Item 262 (8 January 1945). <u>McCullers Collection</u>, Humanities Research Library, University of Texas, Austin.
4. Marguerite Young, "Metaphysical Fiction," <u>Kenyon Review</u> IX (Winter 1947) 151.

5. 'Clyde L. Manschreck, <u>A History of Christianity in the World</u> (New Jersey: Prentice-Hall, Inc., 1974). All general references to the history of Christianity in the current text are based on interpretation of information supplied by this text.

6. Patricia Box, "Androgyny and the Musical Vision: A Study of Two Novels by Carson McCullers," <u>Southern Quarterly,</u> 16 (January, 1978) 117-23.

Chapter 5

1. Oliver Evans, <u>The Ballad of Carson McCullers</u> (New York: Coward McCann, Inc.) 165.

2. Jesse R. Fauset, <u>The Chinaberry Tree</u> (New York: AMS 1969).

3. Evans, 167.

4. Evans, 165.

5. Hans Zinsser, <u>Rats, Lice and History</u> (Boston: Atlantic Monthly Press by Little Brown & Cox. 1935) 212.

6. Zinsser, 227.

7. Evans, 166.

8. Evans, 166.

9. Carson McCullers, "When We Are Lost," <u>The Mortgaged Heart</u>. ed. Margarita Smith (Boston: Houghton Mifflin 1971) 287.

Chapter 6

1. Charlene Clark, "Selfhood and the Southern Past: A Reading of Carson McCullers's <u>Clock Without Hands</u>," <u>Southern Literary Messenger: A Quarterly</u>, Series 3, Vol I, No 2 (1975) 16.

2. Donald Emerson, "The Ambiguities of <u>Clock Without Hands</u>," <u>Wisconsin Studies in Contemporary Literature</u> 3 (Fall 1962) 18.

3. Delma Pressley, "Carson McCullers's 'Descent to Earth,'" <u>Descant</u> (TCU) 17 No.1 (1972) 55.

4. J.N. Hartt, "The Return of Moral Passion," <u>Yale Review</u> LI (December 1961) 301.

5. Louis D. Rubin, Jr., "Six Novels and S. Levin," <u>Sewanee Review</u> 70 No. 3 (1962) 511, 510.

6. Oliver Evans, <u>The Ballad of Carson McCullers</u> (New York: Coward-McCann, Inc. 1966) 180.
7. Richard Wright, <u>The New Republic</u> 5 August 1940. 195.
8. Evans, p. 172.
9. Pressley, p. 57.
10. Emerson, 18.
11. Pressley, 55.
12. Rubin, 510.

Chapter 7

1. Edgar E. MacDonald, "The Symbolic Unity of <u>The Heart is a Lonely Hunter</u>," <u>Festshrift for Professor Marguerite Roberts</u> (Univ. of Richmond Press, Richmond, 1976) 169.
2. Carson McCullers, <u>Clock Without Hands</u>, Houghton Mifflin Company, Boston (The Riverside Press Cambridge: 1961) 229.